Bouguereau

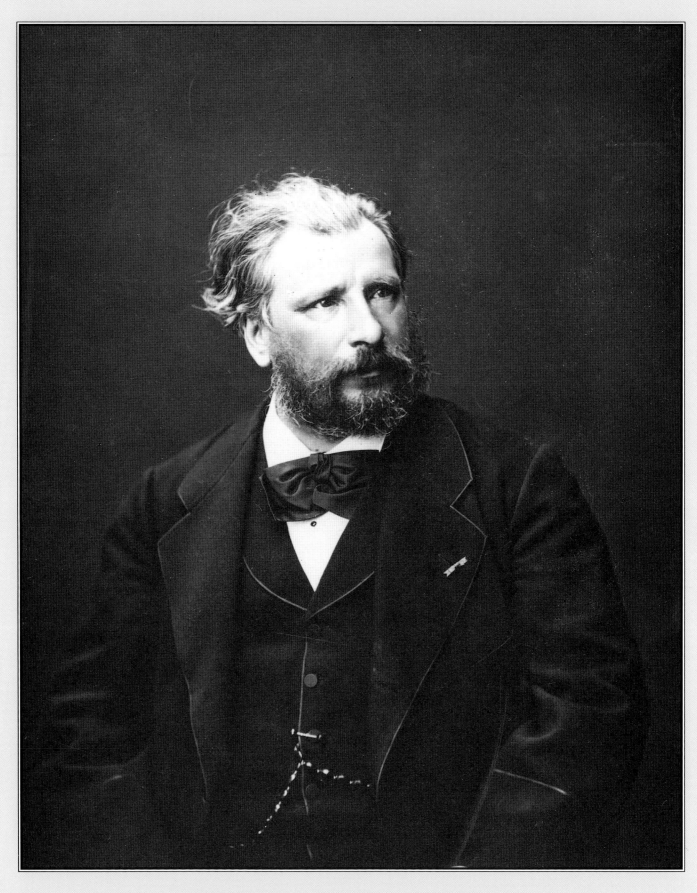

FIGURE 1.

Adolphe-William Bouguereau, c. 1870

Photograph © Collection Viollet.

Bouguereau

FRONIA E. WISSMAN

POMEGRANATE ARTBOOKS SAN FRANCISCO

Published by Pomegranate Communications, Inc.
Box 808022, Petaluma CA 94975
800 227 1428; www.pomegranate.com

Pomegranate Europe Ltd.
Unit 1, Heathcote Business Centre, Hurlbutt Road
Warwick, Warwickshire CV34 6TD, UK
[+44] 0 1926 430111; sales@pomeurope.co.uk

Front cover: *The Bohemian,* 1890
Oil on canvas, 149.9 x 106.7 cm (59 x 42 in.)
The Minneapolis Institute of Arts, The Christina N. and Swan J. Turnblad Memorial Fund, 74.33

Library of Congress Cataloging-in-Publication Data
Wissman, Fronia E.
Bouguereau / Fronia E. Wissman.
p. cm.
Includes bibliographical references.
ISBN 978-0-87654-582-9
1. Bouguereau, William Adolphe, 1825–1905–
Criticism and interpretation. I. Title.
ND553.B8W57 1996
759.4—dc20 95-52941
 CIP

Pomegranate Catalog No. A830
Designed by Bonnie Smetts Design
First Edition
14 13 12 11 10 09 08 07 17 16 15 14 13 12 11 10
Printed in Korea

Contents

ACKNOWLEDGMENTS

No book is written alone. I would like to thank those people who have been of signal help. At Pomegranate, Thomas F. Burke, publisher, had faith in me, and Katie Burke guided the book through production, offering welcome encouragement along the way. Mark Chambers edited the manuscript with speed, cheer, and tact. In Paris, first Fershid Bharucha and then Rosalie Gomes tracked down elusive images. Lynn Federle Orr, Couric Paine, and Andrew Uchin, all at the Fine Arts Museums of San Francisco, formed the conduit through which I came to this project. Hilarie Faberman, Stanford University Museum of Art, and Alexandra Murphy, of Williamstown, Massachusetts, have been sources of constant moral support, and Steven Kern, Sterling and Francine Clark Art Institute, gave material aid. Thierry d'Allant articulated some of the more slippery concepts surrounding the art of Bouguereau. Esther Dean, Research Librarian at the Bennington Free Public Library, arranged for interlibrary loans in record time. Bernard Barryte, Stanford University Museum of Art, and William R. Johnston, the Walters Art Gallery, read the manuscript and offered much-needed and appreciated advice. Bernard's long-standing interest in Bouguereau improved this book immeasurably. And Marc Simpson, without whom I would do nothing, knew when to ask the right questions.

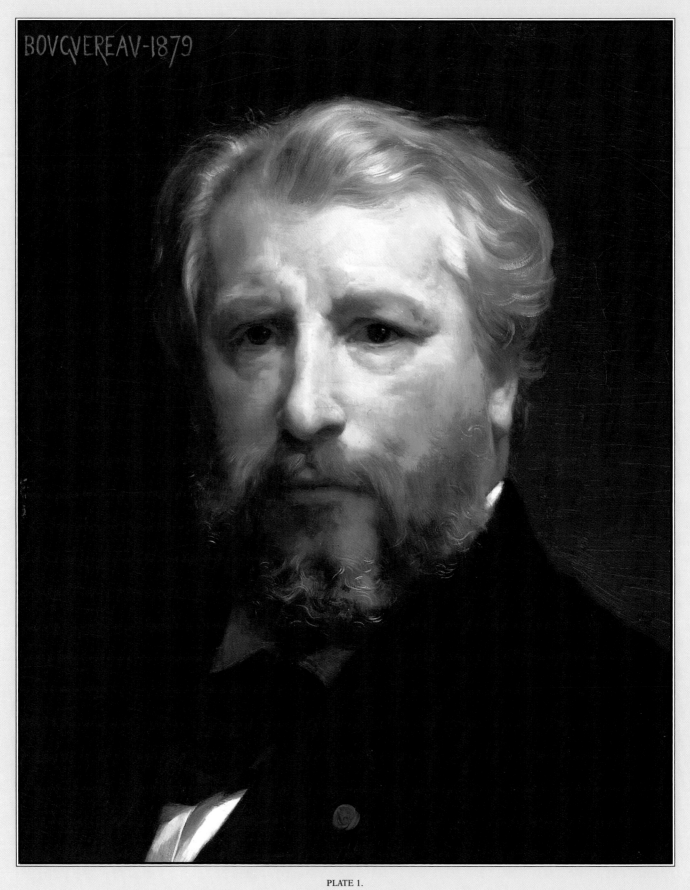

PLATE 1.

Self-Portrait, 1879

Oil on canvas, 46 x 38 cm (18⅛ x 14¹⁵⁄₁₆ in.). The Montreal Museum of Fine Arts, Purchase, Horsley and Annie Townsend Bequest, 1984.16.
Photograph courtesy The Montreal Museum of Fine Arts.

The Life

INTRODUCTION

By the time of William Bouguereau's death, in 1905, he was at once the most reviled and the most beloved of French artists. He was scorned by progressive painters and critics, who saw in his art all that was wrong with the official French world of art. Edgar Degas and his friends used the term Bouguereauté (Bouguereau-ized) to describe a general style, epitomized by Bouguereau's paintings, they considered to be marred by slick and artificial surfaces. Yet Bouguereau was a favorite of collectors, who found in his paintings of bathers, nymphs, and shepherdesses a realm of eternal beauty, at a distance from contemporary life. Bouguereau's career began early and moved ever upward, with no professional setbacks to speak of. If his personal life was not so lucky, it was at the same time filled with not uncommon events. And, if we know less about his daily life than we do about Claude Monet's (1840–1926) or Camille Pissarro's (1830–1903), whose many letters to family, friends, and colleagues were saved and later published, it seems that Bouguereau

would have wanted it that way. His personal life was his own; that which he wanted to share with the world, his art, he did in abundance.

Bouguereau was a man of tradition. Some of his contemporaries, such as Pierre-Auguste Renoir (1841–1919) and Degas (1834–1917), also studied and honored the history of art, but they wanted to recast it in terms, and in a spirit, they felt were more suitable to the nineteenth century. By contrast, Bouguereau was a staunch supporter of the very forms of art that dated back to antiquity. He valued above all else the beauty of the human body. The Greek sculptors Praxiteles and Phidias, the touchstones of this tradition, placed their primary emphasis on the male body, as befitted their culture. Their legacy was revived by the great artists of the Italian Renaissance—Michelangelo, Raphael, Leonardo, and their followers. These artists drew on a broader range of subject matter—both pagan and Christian themes— and were able to expand the aesthetic canon to include the female body, both draped and nude. Bouguereau was beneficiary of this grand, humanistic tradition.

Central to this tradition is the discipline of drawing, especially as it was taught in the nineteenth century in the government-sponsored art schools across Europe. Through careful draftsmanship the successful artist would be able to replicate objects in the real world—human figures, animals, trees and rocks, architecture, and costumes—in order to insert them in his (more rarely, her) paintings. But these elements from the real world were to be idealized, stripped of their imperfections and made more beautiful than they were in actuality, for the paintings in which they appeared were not scenes from everyday life, but scenes that evoked a better, purer time and place. Bouguereau and artists like him used models, living people in the present, to create visions of a world apart. To characterize their works as "escapist" misses the point, for the spotless and adorable children, the nymphs and shepherdesses, and even the Madonnas in this idealizing tradition were drawn from actual life.

YOUTH AND TRAINING

William Bouguereau (he did not use his first name, Adolphe) was born in La Rochelle, on the Atlantic coast of France, on November 30, 1825. In a manner similar to Mozart's display of innate musical skill, Bouguereau, at a very early age, demonstrated his uncanny ability to draw. His uncle Eugène, a curate, educated him, teaching him Latin, Greek myths, and the stories from the Old and New Testaments. This uncle played a crucial role in Bouguereau's life, for he arranged for the boy to go to high school (collège) in Pons, where he took his first drawing lessons. His teacher, Louis Sage (1816–1888), is largely unknown to us today, although it is said that he had trained in the studio of Ingres. Whatever Sage's background, his instruction and Bouguereau's talent combined to produce a solid footing for the boy in the principles of drawing.

Bouguereau's parents, merchants first in wine and then in olive oil, initially wanted him to enter the family business—by the early 1840s based in Bordeaux—and he did so. A client of the elder Bouguereau convinced the father to allow the son to study at the Ecole des Beaux-Arts in Bordeaux for two years, an institution then headed by Jean-Paul Alaux (1788–1858). As often happens, work and study had to make room for each other, and Bouguereau was able to study at the school only early in the morning and late at night. He earned extra money designing lithographic labels for jams and preserves. Nonetheless, in 1844, after only two years of part-time study, Bouguereau won first prize in figure painting for a canvas representing Saint Roch. This prize was the catalyst for Bouguereau's future career.

The center of the art world, however, was in Paris, not Bordeaux, and Bouguereau's father could not afford to send his son to the capital. His mother earned extra money doing needlework, but that effort was of limited use. His uncle the curate stepped in once again, arranging for Bouguereau to paint the portraits of his parishioners at a fixed price, in exchange for room and board. Thirty-three portraits sufficed for him to save nine hundred francs. An aunt matched this sum, which finally gave Bouguereau enough to go to Paris in 1846, at the age of twenty-one. With the recommendation of Alaux from Bordeaux, Bouguereau was accepted into the studio of François-Edouard Picot (1786–1868) and then at the Ecole des Beaux-Arts in Paris, the latter the goal of all art students aspiring to official acceptance.

A brief discussion of the official art world in Paris in the mid-nineteenth century might help to explain why Bouguereau chose the path he did, and why he was so successful once he had mastered its idiosyncrasies. The rulers of the strongly centralized government of France had, for centuries, embellished the state, and their person as an embodiment of that state, with art. From lavishly decorated royal palaces to the war booty Napoleon stole from Italy, art had been used as a political tool to demonstrate the strength and longevity of the French monarchy. The various regimes of the nineteenth century—imperial, republican, monarchal—were no different. They used the multilayered bureaucracy they had inherited to train artists, to provide public exhibitions, and to reward artists who met their criteria. In short, an artist, whether architect, engraver, sculptor, or painter whose works were deemed appropriate by government agencies, could hope for, and in many cases was assured of, a livelihood from commissions both from the government and its network of dependencies—the church, municipalities, institutions, and government agencies—and from the public who saw the works displayed.

Training in Paris took place in the government-sponsored art school, the Ecole des Beaux-Arts, where the students were taught how to draw. At that time the craft of putting paint on canvas was taught elsewhere, that is, in the private studios of the school's professors. Rigorous hurdles, in the form of competitions of increasing difficulty, were placed before the students, the highest hurdle being the Prix de Rome. Only ten students each year competed for this coveted prize. The winner was sent to Rome, to stay for four years at the Villa Medici, the seat of the French Academy in Rome, to study classical art and

the Italian Renaissance masters. This art-training system, then, was oriented to the past, for it was predicated on the notion that no artist since the Renaissance had ever achieved the level of perfection reached by Raphael and Michelangelo. It was the duty, obligation, and responsibility of contemporary artists to embody in the present, and to carry into the future, that tradition.

Just as the training was regulated, so were the forms in which this tradition took shape. Paintings, for example, were ranked by their subject matter. History paintings, stories of noble or tragic acts drawn from history and myth, were accorded first rank. Then came portraits, worthy as likenesses of important personages, then landscapes, and at the bottom, still lifes. The latter two, according to academic theory, were only copies of what the artist could see, and could not carry a message of virtue or morality. Only history painting, with its emphasis on the human body, could properly reflect the training of the government schools and, with judicious choice of subject, glorify the state. Thus, the highest prize, the Prix de Rome, was given to the best history painting; the other genres, with the exception of a new category, historical landscape painting—inaugurated in 1817—did not even have a prize.

The main event in the arts calendar of Paris was the Salon, a huge annual exhibition of contemporary art. As important as the government was in commissioning works of art, there was in fact a limit to the number of churches and governmental buildings needing new decorations and the number of official portraits required. In previous centuries the state, the church, and the aristocracy (an extension of the state) were, broadly speaking, the only institutions powerful and wealthy enough to commission works of art, and therefore to influence what forms art would take. In the nineteenth century, as these institutions began to lose power, they were overshadowed by the growing middle class, who wanted to hang fine art in their homes. Before dealers became established as buyers and sellers of art, which happened around midcentury, the Salon functioned as the supreme marketplace, where consumers could see, in one place, what artists were capable of producing. Success at the Salon, which was dependent on such factors as an advantageous placement of works and favorable reviews in the press, could guarantee for an artist a viable career.

Bouguereau's early artistic life began somewhat inauspiciously. Although he was accepted at the Ecole des Beaux-Arts after only two months in Picot's studio, it was as the ninety-ninth of one hundred pupils accepted. He was chosen as a contestant for the Prix de Rome in 1848 (third of ten contestants), in 1849 (seventh of ten), and again in 1850, when he was the last of the ten competitors chosen. The Prix de Rome he was awarded in 1850, for his *Zenobia Found by Shepherds on the Banks of the Araxes* (see Plate 2), was in fact a kind of second prize, as Paul Baudry (1828–1886) had won more votes. Bouguereau was accorded a trip to Rome in part because there was a vacancy at the Villa Medici; no prize had been awarded in 1848 because of the revolutionary turmoil in France that year.

Living in Italy, for Bouguereau, was a luxury; the prize was four thousand francs, in addition to the six hundred he was given by the Municipal Council of La Rochelle on his entry into the art school in Paris. While there he applied himself to such rigorous study that he earned the nickname of "Sisyphus." In addition to absorbing the lessons to be learned in Rome from antiquity and the work of Renaissance artists, he traveled throughout Italy to copy the masterpieces found in Orvieto, Assisi, Siena, Florence, Pisa, Ravenna, Venice, Parma, Naples, Pompeii, Capri, Bologna, Milan, and Verona. He also visited the hill towns and lakes around Rome—Terni, Narni, Città Castellana, Albano and Nemi, Castel Gandolfo—sites that had inspired landscapists since the seventeenth century. The things he saw during his sojourn in Italy would inform his art for the rest of his life.

EARLY SUCCESS

Upon his return to Paris in early 1854 Bouguereau was awarded valuable commissions in two areas, portraiture and decorative cycles. These opportunities for work came from both Paris and his hometown of La Rochelle. Bouguereau continued to exhibit paintings (some of which had been painted in Rome) at the Salon, where they were received by the public with great favor. Because of his training at the Ecole des Beaux-Arts, and that institution's emphasis on paintings with themes drawn from mythological, classical, and biblical history, the subjects of Bouguereau's early Salon submissions were mostly somber and serious. Titles such as *Combat of the Lapiths and Centaurs* (1852; private collection) and *Le triomphe du martyre: Le corps de Sainte-Cécile apporté dans les catacombes* (The Triumph of the Martyr: The Body of Saint Cecilia Being Carried into the Catacombs) (1854; see Figure 2) indicate that the young artist aspired to take his place in the tradition of grand history painting.

These pictures were not the kind, however, that had wide commercial appeal. His art began to move away from grandiose compositions to more genrelike scenes with fewer figures. Mothers and children, shepherdesses, and children playing were some of the themes that would find a place on the walls of middle-class homes. Bouguereau was a canny businessman. In addition to exploiting the great marketplace of the Salon, he allied himself with dealers who could show his work to advantage and procure for him good prices. Toward the late 1850s his work was beginning to be handled by the dealer Paul Durand-Ruel (1828–1922); after October 1866, Adolphe Goupil (1806–1893) was Bouguereau's exclusive dealer. Beginning in the 1860s Bouguereau's paintings were particularly popular in England and America, where the taste for scenes of domestic sentimentality ran high.

PRIVATE LIFE

Bouguereau's private life only occasionally intersected with his public one. Indeed, most of what we know about the man are his professional activities and the arrangements he made to accommodate his personal life to his public one. An exception is his enlistment in the National Guard in 1848 to fight the insurrectionists who took control of the National Assembly. He enlisted again in 1870 with the outbreak of the Franco-Prussian War, despite his age and his exemption for having been a Prix de Rome winner. But his family life mattered to him more than did politics. In 1856 he married Marie-Nelly Monchablon (1836–1877), a woman about whom little is known. The couple had five children, three sons and two daughters. By September 1868 Bouguereau was successful enough to have a large house and studio built for him and his family (which included his mother after she was widowed) at 75, rue Notre-Dame des Champs, in Montparnasse. On the Left Bank, not far from the Ecole des Beaux-Arts and the Institut de France, the institution that protected the standards and purity of things French, Montparnasse was already popular with artists in the 1840s, when this section of the city was still a place apart. More studios could be found on rue Notre-Dame des Champs than on any other street in Paris. The successful portrait painter Carolus-Duran (1838–1917), the animal painter Rosa Bonheur (1822–1899), and the American expatriate James McNeill Whistler (1834–1903) all had studios there. It says much for Bouguereau that he chose to work and live in a district that had art, not society, as its center.

He sent his family to La Rochelle during the siege of Paris by the Prussians, while he remained behind. At the end of the siege he was able to join them, and they all returned to Paris in September 1871. His domestic happiness was short-lived, however. A daughter, Jeanne-Léontine, died in 1872, presumably in infancy. One of the sons, Georges, died in 1875 at the age of sixteen. In April 1877 Nelly died, and the infant William-Maurice died only two months after her. Bouguereau memorialized these personal losses in two paintings: the first, in 1876, *Pietà* (see Plate 47), dedicated to Georges, and then, only one year later, *Vierge consolatrice* (Virgin of Consolation) (1877; see Plate 48). Another son, Adolphe-Paul, died in 1900, in his early thirties, reportedly from tuberculosis.

Bouguereau said that he was happy only when he was painting. At the end of his life he told a journalist for the *Boston Evening Transcript*: "Each day I go to my studio full of joy; in the evening when obliged to stop because of the darkness I can scarcely wait for the next morning to come. . . . My work is not only a pleasure, it has become a necessity. No matter how many other things I have in my life, if I cannot give myself to my dear painting I am miserable." His productivity corroborates his words; he painted close to seven hundred works during his long life.

Yet he was susceptible to romance, even at a relatively advanced age. A young American artist, Elizabeth Jane Gardner (1837–1922), from Exeter, New Hampshire, lived with a female friend and chaperone next door to Bouguereau and his family at 73, rue Notre-Dame des Champs. Bouguereau expressed the desire to marry Gardner at the end of 1877, but his daughter, Henriette, threatened to enter a convent if he did. Bouguereau's mother also seems to have opposed the match, and by all accounts she was a formidable woman; even her very successful son did not choose to cross her. Nonetheless, Bouguereau and Gardner quietly became engaged in 1879. He must have given her a self-portrait at this time (1879; Plate 1) as a surrogate for the living man. Elizabeth wrote of her engagement to her family in New Hampshire (her letters have been microfilmed by the Archives of American Art) and shed a little light on the subject of Mme Bouguereau.

And now about my engagement. . . . I am very fond of Mr. Bouguereau and he has given me every proof of his devotion to me. We neither of us wish to be married at present. I have long been accustomed to my freedom. I am beginning to attain a part of the success for which I have struggled so long. He is ambitious for me as well as I for myself. As it is I can't help working very much like him. I wish to paint by myself for a while longer. He has a fretful mother who is now not young, 78 I think. She is of a peevish, tyrannical disposition and I know she made his first wife much trouble.

The prospect of a meddlesome mother-in-law was a good enough reason not to marry, yet Elizabeth's own professional ambitions were also a factor.

It seems likely that Bouguereau and Gardner thought that they would be free to marry soon. Yet Mme Bouguereau continued to manage the artist's household, and with an iron hand, from the time of his first wife's death in 1877 until her own in 1896. Gardner relayed her interpretation of these events to her family. "The old lady died on February 18th at the age of 91. Her devoted son who had borne with such affectionate patience all her peculiarities was quite afflicted by the change [in her health]. He had so long had the habit of subordinating every detail of his life to her desires, of which the first was to rule without opposition in his house." Bouguereau and Gardner were married during the prescribed period of mourning. They seem to have been happy for the few years they had together as husband and wife, even traveling to Italy in 1903, the only time Bouguereau visited that country since his sojourn there more than fifty years before.

HONORS AND DEATH

Bouguereau's single-minded application to his art and craft won him all the rewards possible, which were considerable in nineteenth-century France. His first public recognition, of course, was his winning the Prix de Rome in 1850. Shortly after his return from Rome he won a second-class medal at the Universal Exposition in Paris in 1855. He received an imperial commission in 1856, which resulted in the painting *Napoléon III visitant les inondés de Tarascon* (Napoleon III Visiting the Floods of Tarascon) (1856; City Hall, Tarascon), Bouguereau's one foray into contemporary history painting. In 1857 he was awarded a first-class medal at the Salon. Two years after that, in 1859, when he was made a chevalier, he took the first step up the ladder of awards of the Legion of Honor, the system of civil and military awards established by Napoleon in 1802. In 1876, to his great delight, he was made one of the forty life members of the Académie des Beaux-Arts of the Institut de France, the highest official honor available to artists in France. Also in 1876 he was made an officer of the Legion of Honor. The Grand Medal of Honor at the Salon, awarded for his past successes, was given him in 1885, the same year he was made commander of the Legion of Honor. Two years before his death, he attained the rank of grand officer of that organization.

Respected by his fellow artists, Bouguereau was elected president of the painting section of the Salon after the government allowed the artists to run the organization themselves, in 1881. In 1883 he was elected president of the Society of Painters, Architects, Sculptors, Engravers, and Designers, a benevolent society formed to promote the welfare of struggling artists, a position he retained until his death. His influence spread through his teaching drawing at the Ecole des Beaux-Arts, starting in 1888. But perhaps more significant was his time at the Académie Julian, an art school independent of the Ecole des Beaux-Arts, where he began teaching in 1875.

His awards from other countries suggest how active art life was in the nineteenth century. As early as 1862 Bouguereau was named an honorary member of the Belgian Society of Artists, and in 1866 he was made a member of the Royal Academy of Fine Arts of Holland. In 1873 he sat on the jury of the international exposition held that year in Vienna. He won a first-class medal at the international exposition held in Munich in 1879, and the next year he showed at an exhibition in Ghent. In 1881 he was named chevalier in the Order of Leopold by the king of Belgium and was raised to commander in 1895. In 1888 he sat on the jury of the international exposition in Barcelona, and in 1889 he was unanimously voted a member of the Royal Academy of Fine Arts of Belgium and made a member of the honorary order of Spain.

This list of international exhibitions reflects the large degree of open exchange of artistic ideas across national boundaries in the nineteenth century. The exception, so far as France was concerned, was Germany. In 1891, a full twenty years after the Franco-Prussian War, the sting of French defeat still hurt. Bouguereau, along with Jean-Léon Gérôme (1824–1904) and Edouard Detaille (1848–1912), was asked to show works at the international exposition to be held in Berlin. At first, all agreed, but a newspaper campaign was mounted, and Gérôme and Detaille rescinded their acceptances. Bouguereau was alone in sending two paintings, in the face of public opposition, saying that he felt it a patriotic duty to conquer German artists on their own ground. "To abstain would be a desertion," he declared. This was a rare instance of activism on the part of a man who dedicated his life to his art.

Throughout the course of his career, Bouguereau was in the habit of spending the summers in La Rochelle, painting in a studio he had constructed there. After several years of heart disease, he died in La Rochelle on August 19, 1905. It is thought that his condition was exacerbated by the burglary of his house and studio in Paris that spring, one of a string of robberies in the neighborhood. He is buried in the cemetery of Montparnasse, near the neighborhood where he had lived.

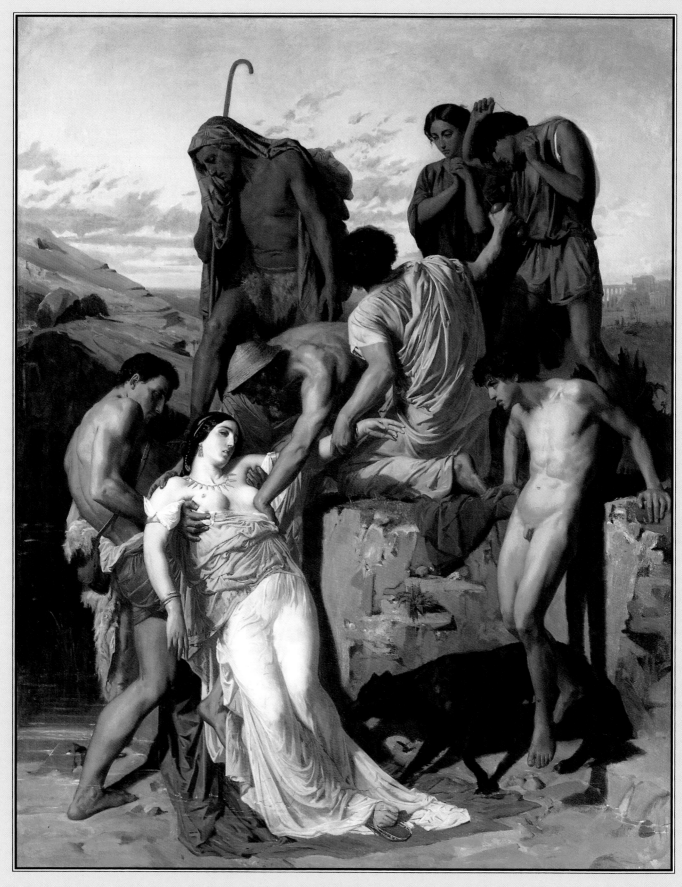

PLATE 2.

Zenobia Found by Shepherds on the Banks of the Araxes, 1850

Oil on canvas, 147 x 113 cm (57⅞ x 44½ in.). Ecole des Beaux-Arts, Paris.

T h e P a i n t i n g s

EARLY HISTORY PAINTINGS AND DECORATIVE CYCLES

Bouguereau's early work, not surprisingly, follows the pattern he had worked so hard

in school to learn. He applied his energies to producing paintings that would find

favor with the Salon jury. The challenge of the Prix de Rome competition, in which all

ten contestants painted a work of an assigned subject, was to create a composition

both novel and intelligible. The students were expected to be conversant with the

themes drawn from Greek and Roman myth and history and from the Bible. The

emphasis was on the human figure and how it expresses emotions ranging from joy to

deepest sorrow. The winning entry demonstrated the student's ability to depict the

human form in such a way that the narrative was easily read. Bouguereau's entry of

1850, *Zenobia Found by Shepherds on the Banks of the Araxes* (Plate 2), tells a story

that was presumed to be familiar to the art students and at least a portion of the hun-

dreds of thousands of visitors to the Salon. The story relates a little-known episode

from the eastern reaches of the Roman empire, and it is not surprising that it is no

longer part of common knowledge. Zenobia and her husband, Rhadamistus, were forced to flee their palace when their subjects, the Hiberii, revolted to prevent Rhadamistus from attempting to invade Armenia again. Zenobia's pregnancy slowed the couple's flight. Rather than letting her be captured by the enemy, Rhadamistus stabbed her and threw her body into the river Araxes. The scene chosen for the competition was the moment when shepherds find Zenobia, whom they nurse back to health.

Bouguereau has placed eight figures into his scene, all in different postures, all doing different things. The viewer's eye is not distracted by the activity, however, since it is riveted to the deathly pallor of Zenobia's flesh, so pale from loss of blood and immersion that the color almost matches her white drapery. Although to our eyes some of the gestures and expressions may seem theatrical or exaggerated, the narrative is still readily understood. Particularly noted by contemporary reviewers was the male figure on the right, caught in midair as he lowers himself to the riverbank. Yet in addition to carefully orchestrating dramatic tension, Bouguereau included such naturalistic details as the sandal about to fall off Zenobia's foot and the altogether fitting shepherds' dog, here come to sniff the unfamiliar object. *Zenobia Found by Shepherds on the Banks of the Araxes* and all the other paintings that have won the Prix de Rome are in the collection of the Ecole des Beaux-Arts, to function as exempla for future students.

Bouguereau continued to paint serious and weighty subjects, such as *Dante and Virgil in Hell* (1850; private collection) and *Le triomphe du martyre* (1854; Figure 2). These paintings are large. They had to be. Paintings sent to the Salon competed for visitors' attention with several thousand others. Not all the pictures that were submitted and accepted were large, but many were, and a large size could accommodate a greater number of figures. The eight figures in *Zenobia* were fit into a canvas measuring 58 by 44 inches, small by Salon standards. For *Le triomphe du martyre*, which is over eleven feet high and fourteen feet wide, Bouguereau gave himself the luxury of painting the eighteen figures life-size. Perhaps he was inspired to paint such a huge canvas by the frescoes he had been seeing during the three years he was in Italy (*Le triomphe du martyre* was painted in Rome). This large work earned Bouguereau instant acclaim when it was exhibited at the Universal Exposition of 1855. It was bought by the French government and hung in the museum of contemporary art in Paris, the Luxembourg.

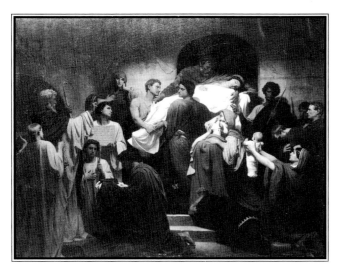

FIGURE 2.

Le triomphe du martyre:
Le corps de Sainte-Cécile apporté dans les catacombes
(The Triumph of the Martyr: The Body of Saint Cecile Being
Carried into the Catacombs), 1854
Musée Municipal, Lunéville. Photograph © LL-Viollet.

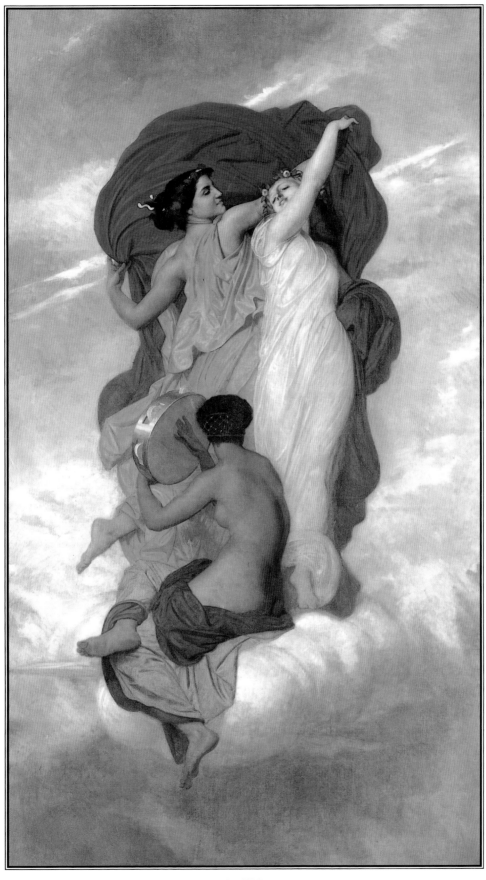

PLATE 3.

La danse (The Dance), 1856

Oil on canvas, 367 x 180 cm (144½ x 70⅞ in.). Musée d'Orsay, Paris. Photograph courtesy Lauros-Giraudon.

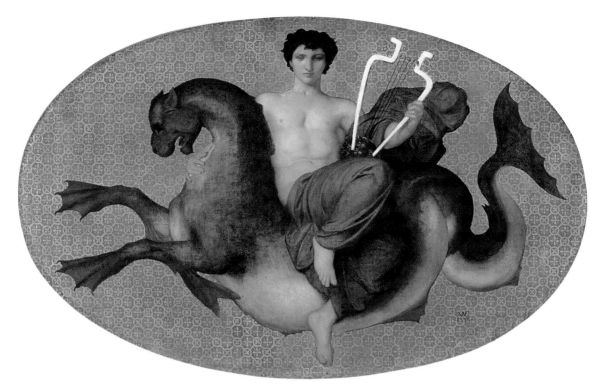

PLATE 4.

Arion on a Seahorse, 1854

Oil on canvas, 71 x 112 cm (27^{15}/$_{16}$ x 44^{1}/$_{8}$ in.) (oval). © 1996 The Cleveland Museum of Art, Bequest of Noah L. Butkin, 80.238.

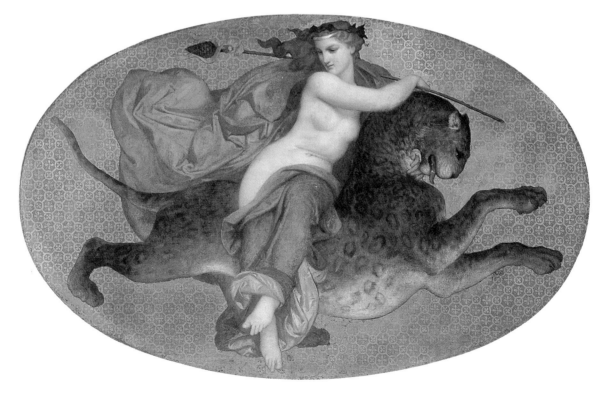

PLATE 5.

Bacchante on a Panther, 1854

Oil on canvas, 71 x 112 cm (27^{15}/$_{16}$ x 44^{1}/$_{8}$ in.) (oval). © 1996 The Cleveland Museum of Art, Bequest of Noah L. Butkin, 80.239.

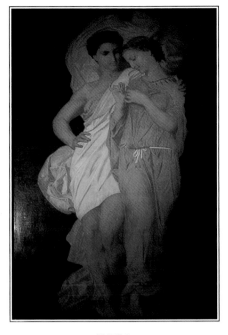 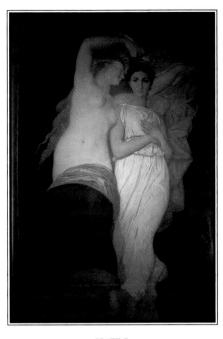 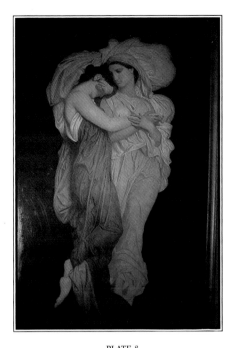

PLATE 6.
L'amour (Love), 1855
Oil on canvas, 269.2 x 149.9 cm (106 x 59 in.).
U.S. Embassy, Paris. Gift of Mrs. Chester Dale.
Photograph by Dominique Chandru.

PLATE 7.
La fortune (Fortune), 1855
Oil on canvas, 269.2 x 149.9 cm (106 x 59 in.).
U.S. Embassy, Paris. Gift of Mrs. Chester Dale.
Photograph by Dominique Chandru.

PLATE 8.
L'amitié (Friendship), 1855
Oil on canvas, 269.2 x 149.9 cm (106 x 59 in.).
U.S. Embassy, Paris. Gift of Mrs. Chester Dale.
Photograph by Dominique Chandru.

There was an inherent problem with these monumentally sized pictures, however. Who, other than institutions such as the state or the church, was going to buy them? As we shall see, Bouguereau continued to paint pictures with themes drawn from Greek mythology and the Bible, but the market for them was not very big. The importance for the artist of pictures like these may have been their impact on critics and the public, the goal being the establishing of name recognition, rather than whether a specific work was sold. The talent and skill Bouguereau demonstrated in these early exhibition pictures were sufficient to attract clients who commissioned him to execute decorative cycles for churches (the life of Saint Louis for a chapel in Sainte-Clotilde; scenes from the lives of saints Peter, Paul, and John the Baptist for the church of Saint-Augustin; and scenes from the life of the Virgin for the church of Saint-Vincent-de-Paul, all in Paris) and private residences, or *hôtels*, in both Paris (Hôtel Bartholony [alternate spellings include Bartholoni and Barthélémy] and Hôtel Pereire) and La Rochelle (Hôtel Monlun; *La danse* [The Dance] [1856; Plate 3]).

Arion on a Seahorse (1854; Plate 4), *Bacchante on a Panther* (1854; Plate 5), *L'amour* (Love) (1855; Plate 6), *La fortune* (Fortune) (1855; Plate 7), and *L'amitié* (Friendship) (1855; Plate 8) formed part of a cycle for the *hôtel* of Etienne Bartholony on the rue de Verneuil, exhibited at the Salon of 1857 before their integration into the building. *Spring* (1858; Plate 9) was painted for the ceiling of the *hôtel* of the banker Emile Pereire on the rue du Faubourg Saint-Honoré; Bouguereau decorated two rooms, and Alexandre Cabanel (1823–1889) did a third, making it one of the most ambitious and sumptuous projects

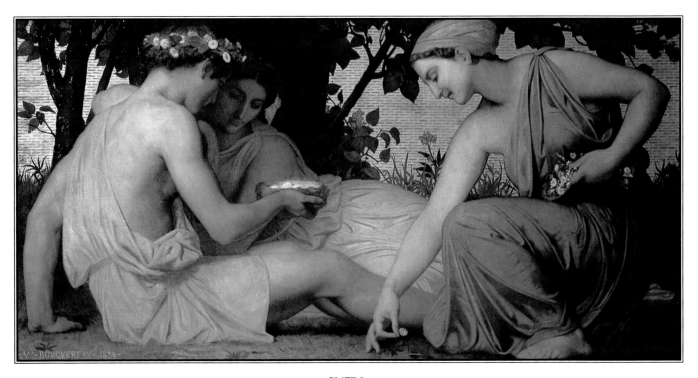

PLATE 9.

Spring, 1858

Oil on canvas, 49.7 x 151.8 cm (19⁹⁄₁₆ x 59¾ in.). Private collection. Photograph courtesy AKG London.

for private consumption. Bouguereau's panels are almost static. In the case of *Arion* and *Bacchante*, the human and animal figures are presented hieratically. The frontal poses of the human figures are animated by slight turns of the body, in contrast to the heraldic profiles of the accompanying beasts, magnificent animals whose undulating curves and eccentric outlines stand out against the patterned backgrounds. In *Spring* Bouguereau followed a centuries-old tradition of room decoration using the Four Seasons as a theme. What one notices first are the arabesques created by the outlines of the three large figures that fill the picture surface. Arm leads to head, which leads to other arm, which leads to hip, which intersects arm bridging the distance between ground and head, which then follows upper arm to elbow and down in a sweeping curve to foot. The figures, draped in pastel robes, are delighting in the rebirth of spring. Eggs in a bird's nest and lovely flowers to be woven into another crown are evidence of earth's riches, symbolized, etherealized, made eternal by the shimmering gold background. Clément de Ris, a contemporary reviewer, observed:

M. Bouguereau has a natural instinct and knowledge of contour. The eurythmie of the human body preoccupies him, and in recalling the happy results which, in this genre, the ancients and the artists of the sixteenth century arrived at, one can only congratulate M. Bouguereau in attempting to follow in their footsteps. . . . Raphael was inspired by the ancients when he drew the design in his rooms [the Stanze in the Vatican are meant here], and no one accused him of not being original. In the same way,

in taking Raphael as a point of departure, M. Bouguereau shows that modern sentiment could accommodate itself to an ancient form.

Such words must have pleased Bouguereau, for he admired Raphael greatly. One of the requirements attendant on winning the Prix de Rome was to send a copy of an old-master painting to Paris; Bouguereau chose Raphael's famous *Le triomphe de Galatée* (The Triumph of Galatea) (1853; Figure 3).

If decorating the houses of wealthy people was an honor, the chance to decorate a public building was the crowning achievement of a traditionally trained artist. Such work was so important to Bouguereau that he sought out these commissions over a period of many years, well after his reputation was firmly established. He received several such commissions over the course of his career, and three churches in Paris are enriched with his paintings. As a devout Catholic (although La Rochelle was a refuge for Protestants and the artist's mother was Protestant, he was brought up in his father's faith), Bouguereau may have viewed these commissions as acts of devotion. Sainte-Clotilde was the first, in 1859; Saint-Augustin followed in 1867; and the cycle for Saint-Vincent-de-Paul was executed in the mid-1880s. The church was still a motivating force in the production of art in the late nineteenth century; indeed, Saint-Augustin was the most important and fashionable church built during the Second Empire of Napoleon III (1852–1870), begun in 1860. Bouguereau was, of course, not the only artist to want to see his art permanently on display in a public building. Artists throughout the nineteenth century usually considered more progressive than Bouguereau, such as Camille Corot (1796–1875), Eugène Delacroix (1798–1863), and Pierre Puvis de Chavannes (1824–1898), equally enlarged their work to mural proportions and turned their hand to traditional Christian subject matter in churches across Paris.

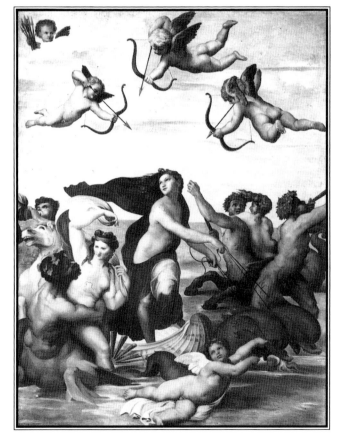

FIGURE 3.

Le triomphe de Galatée (*The Triumph of Galatea*), 1853
Musée de Dijon. Photograph © LL-Viollet.

For Sainte-Clotilde, Bouguereau painted scenes from the life of Saint Louis, the patron saint of France (*Saint Louis Rendering Justice* [1859; Plate 10] and *Saint Louis Caring for the Plague Victims* [1859; Plate 11]). If these scenes, stacked three

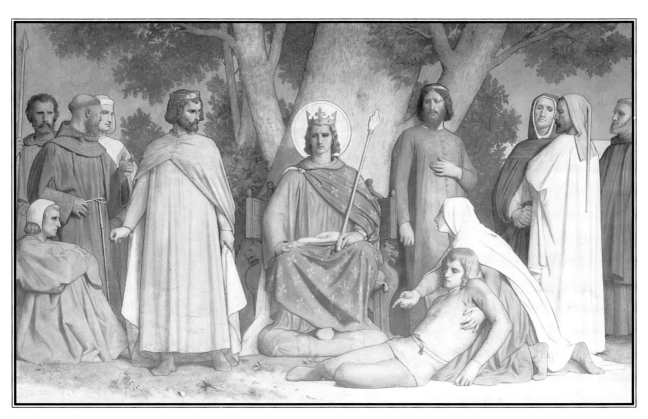

PLATE 10.

Saint Louis Rendering Justice, 1859

Mural, 167 x 292 cm (65¾ x 115 in.). Chapel of Saint Louis, in the church of Sainte-Clotilde. Photograph courtesy SOAE, Ville de Paris.

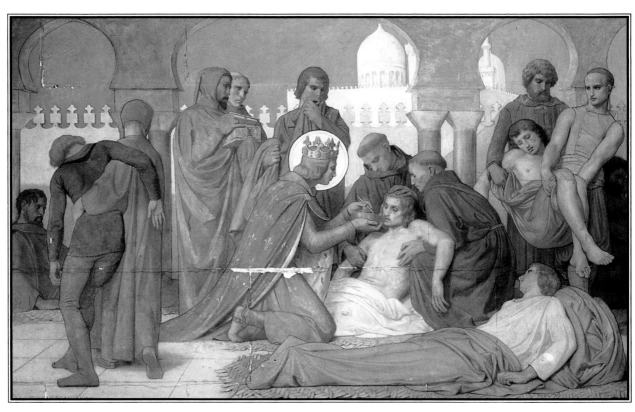

PLATE 11.

Saint Louis Caring for the Plague Victims, 1859

Mural, 167 x 292 cm (65¾ x 115 in.). Chapel of Saint Louis, in the church of Sainte-Clotilde. Photograph courtesy SOAE, Ville de Paris.

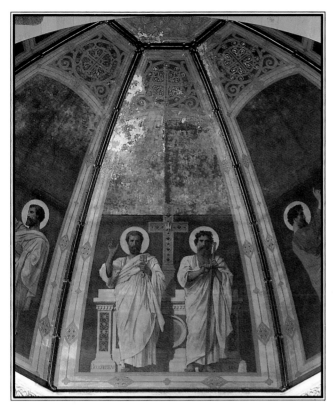

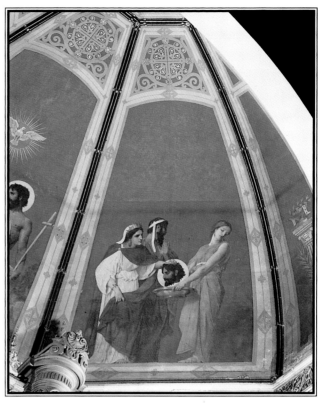

PLATE 12.

Saint Peter and Saint Paul, 1867

Church of Saint-Augustin. Photograph courtesy SOAE, Ville de Paris.

PLATE 13.

Salomé with the Head of John the Baptist, 1867

Church of Saint-Augustin. Photograph courtesy SOAE, Ville de Paris.

high, seem unrelated stylistically to other works by Bouguereau from the late 1850s, it is because he and the other artists decorating the church were executing designs laid out by François Picot, Bouguereau's former teacher. That Bouguereau and the other four painters accepted a commission that would not allow them to paint in their own styles suggests the importance of such public projects. Picot had wanted to replicate the effect of trecento Italian frescoes, and, while Bouguereau's contributions have a certain stiffness and planarity that was doubtless seen as conforming to fourteenth-century Italian models, they resemble more closely the work of the Nazarenes, a group of German artists working in Rome in the early nineteenth century who tried in their art to return to the spirit of the Middle Ages.

More in a style recognizable as Bouguereau's own are the decorations in the cupolas of the chapels of saints Peter and Paul and John the Baptist in the church of Saint-Augustin, completed in 1867 (*Saint Peter and Saint Paul* [Plate 12] and *Salomé with the Head of John the Baptist* [Plate 13]). The architecture of the church required that the figures be painted in as monumental a style as possible, to let them be seen from the floor below. Bouguereau was ready to meet the challenge. Because fewer figures appear here than in the panels in Sainte-Clotilde, each can be appreciated for its individual merits. Especially striking are saints Peter and Paul, frontal and hieratic, with fluid draperies recalling Greek sculpture rather than the more schematic medieval forms of Sainte-Clotilde. Bouguereau's interpretation of

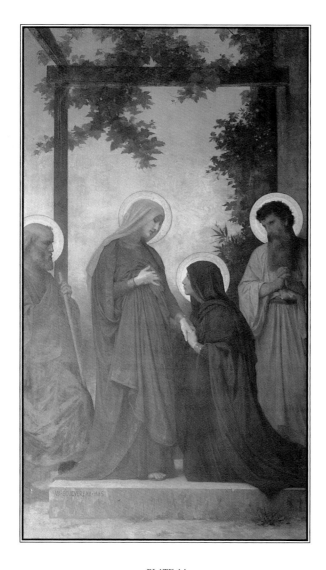

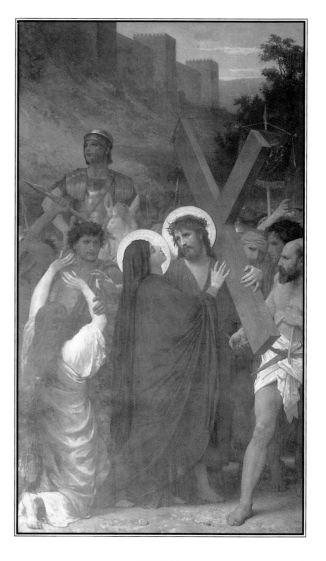

<div align="center">

PLATE 14.

The Visitation, 1885

353 x 190 cm (139 x 74¾ in.). Church of Saint-Vincent-de-Paul.
Photograph courtesy SOAE, Ville de Paris.

</div>

<div align="center">

PLATE 15.

*Christ Meeting His Mother on the Way
to Calvary, 1888*

Oil on canvas, 354 x 199 cm (139⅜ x 78⅜ in.). Church of Saint-
Vincent-de-Paul. Photograph courtesy SOAE, Ville de Paris.

</div>

Salomé as she presents John the Baptist's head is not the usual one of triumph. This Salomé is almost demure, perhaps ashamed, perhaps revulsed, perhaps repentant. Bouguereau introduces an unexpected element of pathos into the well-known story.

Almost twenty years later, in the 1880s, Bouguereau, with assistants, completed, over a period of several years, decorations for the chapel dedicated to the Virgin in the church of Saint-Vincent-de-Paul. *The Visitation* (1885; Plate 14) and *Christ Meeting His Mother on the Way to Calvary* (1888; Plate 15) were exhibited at the Universal Exposition of 1889, as various scenes from the cycle for Sainte-Clotilde had been shown at the Salon of 1861. Even this late in his career, Bouguereau still considered it important to exhibit in this most public forum the recent paintings he deemed to be his best. The Salons and the enormous international expositions, or world fairs, continued to be the most prestigious venues, if for the

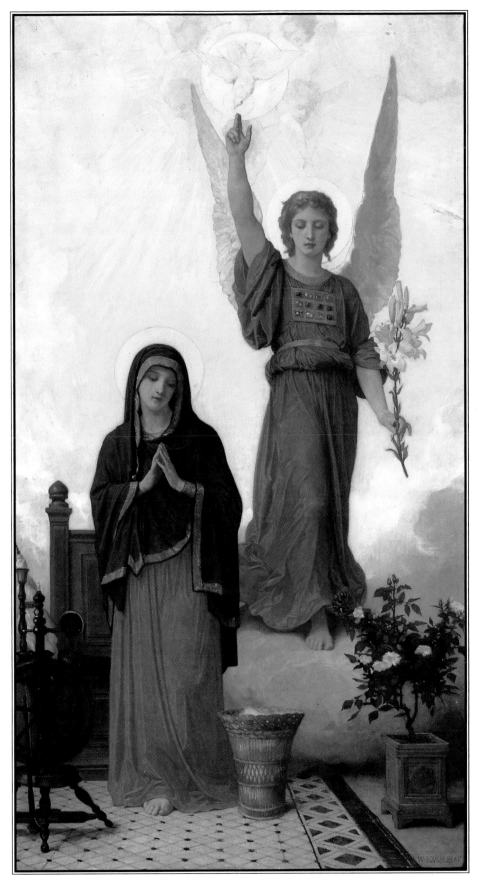

PLATE 16.

The Annunciation, 1888

Oil on canvas, 92.7 x 50.8 cm (36½ x 20 in.). © 1996 Sotheby's, Inc.

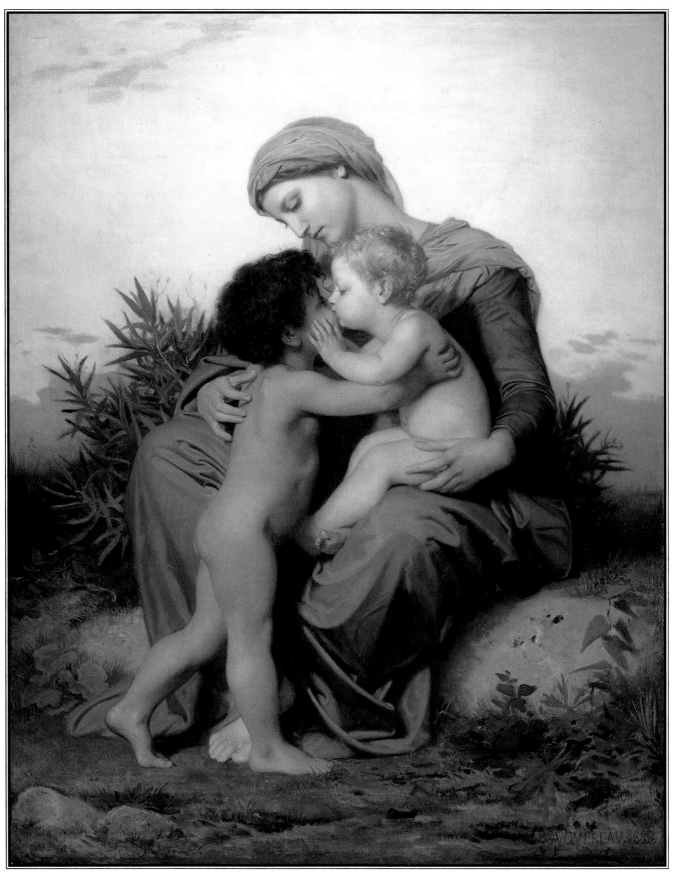

PLATE 17.

Fraternal Love, 1851

Oil on canvas, 147.0 x 113.8 cm (57⅞ x 44¾ in.). Gift of the estate of Thomas Wigglesworth, 08.186. Museum of Fine Arts, Boston.

simple reason of the huge numbers of people who attended them. The combination of a public commission and public exhibition was hard to beat. Such exposure guaranteed that an artist's name would not be forgotten. In addition, artists made replicas and reductions of popular images, and dealers, such as Durand-Ruel and Goupil, did a brisk business in them. *The Annunciation* (1888; Plate 16) reproduced here is a smaller version of the scene from Saint-Vincent-de-Paul that was shown at the Universal Exposition. Customers of a conservative bent, such as those who would be attracted by a Bouguereau rather than by a Monet or a Degas, might well prefer a known quantity, a work that already bore a stamp of approval, a painting their guests would recognize as validated by public taste.

THE CHANGE TO GENRE

But commissions from private patrons and the church would not support a man and his growing family. Perhaps understanding that these complex commissions could not sustain him throughout what he hoped would be a long career, and that the large history paintings were hard to sell, Bouguereau began as early as 1851 to paint a kind of picture that is not easily categorized but is nonetheless immediately appealing. *Fraternal Love* (1851; Plate 17) is the artist's title for such a picture. After it was brought to the United States sometime before 1869 by the Boston collector Thomas Wigglesworth, it was known as *Madonna and Child with John the Baptist*. This is an interesting shift. The American audience readily understood that Bouguereau had deliberately borrowed the composition from a type of Madonna and Child established by Raphael and that by dressing the woman in blue the artist recalled the tradition of the celestial robe of the Virgin Mary. While the popular title is more true to the form and spirit of the picture than was Bouguereau's purposefully vague one, it is important to note that the latter (the one used now, for the sake of historical accuracy) turns a religious picture into a genre scene. This makes the picture more marketable, reflecting the growing importance of the middle-class consumer, who would be more likely to buy an image of a secularized Madonna than of an unambiguous Nativity scene, for example.

The impetus for Bouguereau's secularized Madonnas and other pictures of more indeterminate genre may have been the dealer Paul Durand-Ruel, for, in addition to showing paintings at the Salon in the hopes of finding patrons, Bouguereau, in an attempt to expand his market, also placed his works with dealers. At first his works were handled by Durand-Ruel, whose later career is better known to us as the champion of the Impressionists. Paul Durand-Ruel, taking over the family business that had begun as a stationer's shop, was a man of eclectic tastes. Following the lead of his father, he began to handle the works of Jean-François Millet (1814–1875), Théodore Rousseau (1812–1867), Jules Dupré (1811–1889), Narcisse Diaz (1808–1876), and the now lesser known François Français (1814–1897), Louis Cabat (1812–1893), and Camille Flers (1802–1868). Durand-Ruel was attracted by Bouguereau's work as soon as the latter returned from Rome. A gentlemen's agreement between them resulted in Bouguereau's hand-

ing over to Durand-Ruel almost his entire production for a ten-year period.

It was during this association with Durand-Ruel that Bouguereau's art underwent the change that solidified his reputation and made him one of the most popular French artists of the late nineteenth century. Crucial to this change was Durand-Ruel himself, who also championed the work of the artist Hugues Merle (1823–1881). Merle made his reputation with genre scenes, often with religious overtones, such as scenes of mothers and children, as in his *Mother and Child* (c. 1865; Figure 4), which, like Bouguereau's, can be seen as secularized versions of the Madonna and Child. Durand-Ruel introduced the two artists in 1862 and encour-

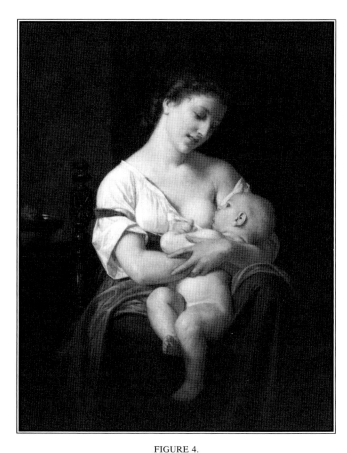

FIGURE 4.

Hugues Merle (French, 1823–1881)
Mother and Child, c. 1865

Oil on canvas, 24.5 x 19.2 cm (9⅝ x 7⁹⁄₁₆ in.). © 1996 Sterling and Francine Clark Art Institute, Williamstown, Massachusetts.

aged Bouguereau to try his hand at this other kind of picture, convinced that they would sell better than the more somber subjects Bouguereau had been favoring. Bouguereau's talents were eminently well suited to the simpler compositions of genre scenes, in which sentiment took the place of narrative, and he profited from the suggestions of Durand-Ruel. But the art market, then as now, is a business, and personal loyalties are sometimes fickle. The dealer Goupil, whose firm began by selling prints and continued to do a brisk trade in reproductive prints, tempted Bouguereau with double the prices Durand-Ruel offered. By October 1866, Bouguereau's paintings could be bought exclusively at Goupil's, as could those of Merle.

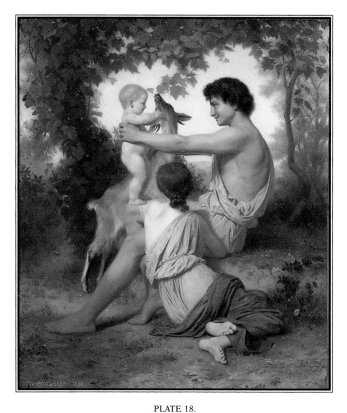

PLATE 18.

Idyll: Family from Antiquity, 1860

Oil on canvas, 59.7 x 48.3 cm (23½ x 19 in.).
Gift of Charles E. Gross in memory of his brother W. H. Gross,
1913.1. Wadsworth Atheneum, Hartford, Connecticut.

Bouguereau's pictures for Durand-Ruel were of two basic types: women in regional Italianate costume (Léopold Robert [1794–1835] began the vogue in the early nineteenth century for scenes of idealized Italian peasants), usually with a child, and classicizing themes, such as *Idyll: Family from Antiquity* (1860; Plate 18). In both kinds of pictures Bouguereau domesticated the severity of antiquity. The Parisian public embraced these peasants, who, unlike those painted by Jean-François Millet, were clean, comely, posed no threat to the social order, and, because they were either placed firmly in the past or were geographically removed, did not remind viewers of the difficult lives led by their own rural countrymen. Critics responded to such scenes with phrases recalling the ancient poets Theocritus and Virgil and the paintings of shepherds by the seventeenth-century painter Nicolas Poussin (1594–1665).

What the critics were responding to was Bouguereau's mastery of composition and evocation. His figures are carefully and correctly drawn. They are idealized but still real bodies, and he sometimes covers them with draperies that recall those on classical Greek sculpture. The critics felt free to fill their reviews—which appeared in the daily newspapers—with allusions to classical art and writings and to examples from the French artistic tradition, confident that their audience would be able to understand the connections. Such is not now the case, for it is no longer common knowledge that Theocritus was a Greek poet in the third century B.C. who created the genre of pastoral poetry, extolling the charms of the easy life in the countryside led by shepherds and shepherdesses whose days are filled with music- and love-making. Virgil, author of the *Aeneid*, is probably better known today, but the references are not to the epic but to the poet's *Bucolics* and *Eclogues*, which translated Theocritus's Greek forms into the Roman idiom.

Bouguereau's antique shepherds are also symptomatic of a general dissolution of categories of painting that had been observed since the seventeenth century. In the late eighteenth and early nineteenth centuries, scenes of shepherds set in antiquity were sometimes given specific titles that identified the figures with venerable antecedents, most often the lovers Daphnis and Chloë. The subjects of history painting, stories from Greek and Roman history and mythology or Christian teachings, began to be supplanted in art by scenes

PLATE 19.

Marguerite, 1868

Oil on canvas, 63.0 x 22.5 cm (24¾ x 8⅞ in.) (oval).
Museo de Arte de Ponce, The Luis A. Ferré Foundation, Inc.,
Ponce, Puerto Rico.

of everyday life. In his paintings of antique shepherds, Bouguereau had it both ways: allusions to classical prototypes allied pictures like *Idyll: Family from Antiquity* with venerable traditions, yet the domestication of the shepherds, as if they were just any family group enjoying a moment of play with child and pet, linked the picture to the growing interest in genre scenes.

If these classicizing shepherds are derivative of older art, both in form and inspiration, *Marguerite* (1868; Plate 19) and *The Secret* (c. 1876; Plate 20) represent other forms of genre painting. *Marguerite* trades on the popularity of Charles Gounod's opera *Faust*, produced for the first time in 1859. Only the title gives a clue as to the painting's subject: Faust, on the advice of Mephistopheles, used a casket of jewels in an effort to seduce Marguerite. Bouguereau has depicted the winsome Marguerite, delighted by her find, looking over her shoulder as if searching for the person who left her the treasures. No hint is given of the tragedy that lies ahead for both Faust and Marguerite; in this presentation the story is sanitized. *The Secret*, instead of borrowing literary themes from the past, reconfigures a story from a contemporary painting by Merle, now unlocated. The differences between Merle's composition and Bouguereau's are telling. In Merle's scene the woman telling the secret turns to face the other, who throws up her hands in surprise or perhaps even shock. The boy is older and in the act of trying to pull the secret-teller away, and the scene includes other figures in the background, making the necessity of a secret obvious. Bouguereau's version is curiously drained of urgency, even of narrative. The secret-teller looks sly, perhaps even malicious, and her fingers actually grip the shoulder of the other woman. The woman who hears the secret appears uninvolved, as if what she is hearing has no bearing on her whatsoever. What does Bouguereau give us instead of an easily read narrative? He gives us impeccable draftsmanship, a sure sense of composition, vibrant colors and subtle patterns, and disconcertingly pretty faces. Were we distracted by a story or subject matter, our attention would not be focused on the artistic skill being offered for our delectation. Two women, dressed in generic clothes meant to signify "countryside," meet by a fountain that seems more like a garden ornament than a functional place from which to draw water. The form of the fountain is consonant with the painting itself— a sophisticated arrangement of color, line, and subtle textures, arranged to attract and delight the eye. For Bouguereau, a painting was meant to be "decorative," and the term was not pejorative but honorific, reaching back into history to take its source and strength from some of the greatest works of the Western tradition: from Pompeian wall paintings to cycles in churches by the greatest of Italian artists, from the anonymous mosaic craftsmen of Ravenna to Raphael in the Vatican Stanze.

Yet if *The Secret* is ambitious in terms of what would become Bouguereau's more typical works, it is still a radical change from the earlier history paintings such as those telling the stories of Zenobia or Saint Cecilia. Instead of many figures, the canvas concentrates on but a few. Instead of complex patterns formed by many limbs, draped and undraped, lines are simplified, comparatively minimized. It takes greater confidence to allow the viewer's full attention to dwell on a few forms, to give the eye fewer distractions. Working in tandem with the greater simplification is the life-size scale Bouguereau adopted for

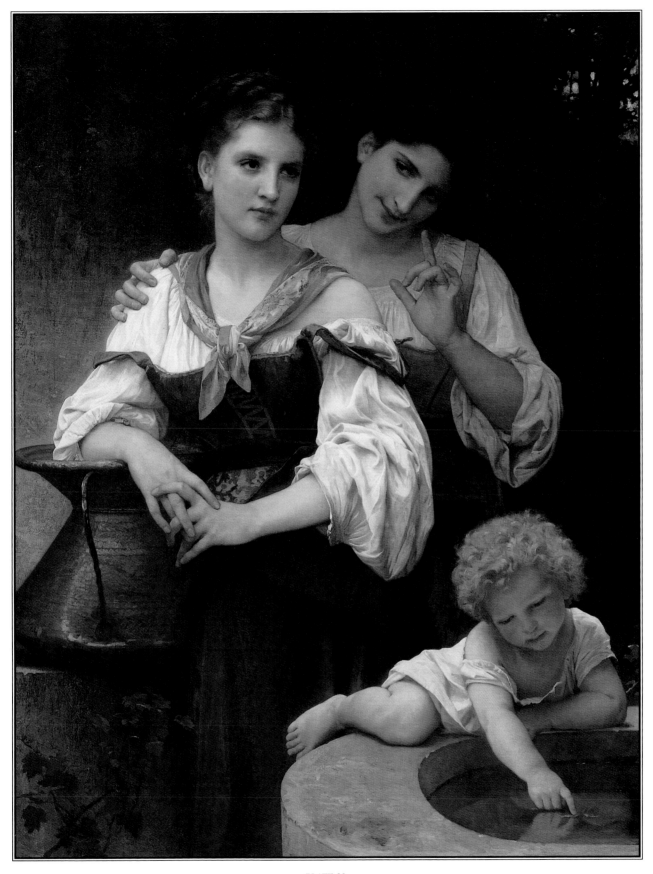

PLATE 20.

The Secret, c. 1876

Oil on canvas. The Robert L. Stuart Collection, on permanent loan from the New York Public Library, S-176.
Collection of The New-York Historical Society.

these pictures. We confront these figures as equals; their fully modeled forms seem to have palpable presence. The deep, rich colors of their clothes give additional weight to the pictures, drawing the eye from whatever else may be in the room; they are compelling images. This monumentality and sureness of compositional construction are evident in Bouguereau's works early on, as in *La tricoteuse* (The Knitting Girl) (1869; see Plate 30) or *Fraternal Love* (see Plate 17).

For Bouguereau, the forms and visual impact are what count, sometimes to the exclusion of evocative or descriptive titles. Louis Sonolet, writing in the *Revue des Charentes* in 1905, noted: "For him form is the supreme object of art. . . . For him a picture is but a theme of lines and colors. So true is this that he is often embarrassed to find titles for his canvases." Some of the titles of Bouguereau's works barely distinguish the paintings one from another. *The Elder Sister, The Kiss, First Caresses, Sleeping Infants, Shepherdess, Italian Woman at the Fountain, Sleep, Bather*: these are not titles that describe a specific image but rather designate a class of image. Such a list reveals the general themes that preoccupied him—and his customers—over the years. A gentle exoticism appeared in the form of models in Italian or rural dress, or undress, in the case of bathers, and in an emphasis on women and children. These themes are by no means original with Bouguereau. Part of his success lay in painting images that had already proven popular with his audience and in his skill at balancing the sentimentality of these subjects— which in lesser hands easily became trite—with fresh formal and compositional structures.

But it would be a mistake to try to force Bouguereau's pictures into a few easily categorized groups: peasants, mothers and children, bathers. For, while many of his works do indeed conform in general tenor to these groups, many do not. *Le jour des morts* (All Saints' Day) (1859; Plate 21) is a work that forms part of a series of paintings dealing with themes of loss and deprivation. Two women, perhaps a mother and daughter, lay a wreath on a grave. Their deep mourning suggests that they have lost their husband and father, and the solemnity with which the artist portrays the scene recalls the mood of ancient Greek grave reliefs. For these pictures of particularized sadness, Bouguereau chose to dress his figures in contemporary attire. Similarly placed in the nineteenth century are the mother and daughter in *The Thank Offering* (1867; Plate 22). Here, a tender offering to a statue of the Virgin in a household shrine is made to hasten the recovery of a sick child. (Bouguereau's title for it was just that, *The Sick Child*.) To our eyes, a scene like this may suffer from an overdose of sentimentality, but in the nineteenth century such simple piety was sincere and widespread. Infant and childhood mortality were facts of life in the absence of sterilization and widespread inoculation (the English physician Edward Jenner began experimenting with inoculations against smallpox only in 1796), but the loss of a child to illness would nonetheless have been a wrenching experience.

Bouguereau explores more directly the plight of children in distress in *Indigent Family (Charity)* (1865; Plate 23). He shows us a woman with three children huddled in front of the church of the Madeleine in

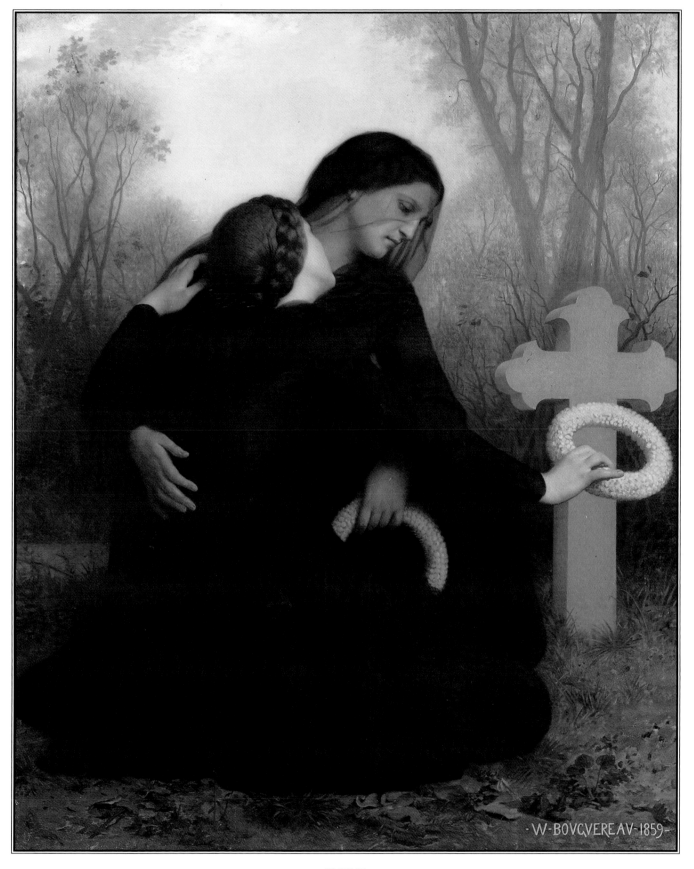

PLATE 21.

Le jour des morts (All Saints' Day), 1859

Oil on canvas, 147 x 120 cm (57⅞ x 47¼ in.). Musée des Beaux-Arts, Bordeaux. Photograph courtesy Lauros-Giraudon.

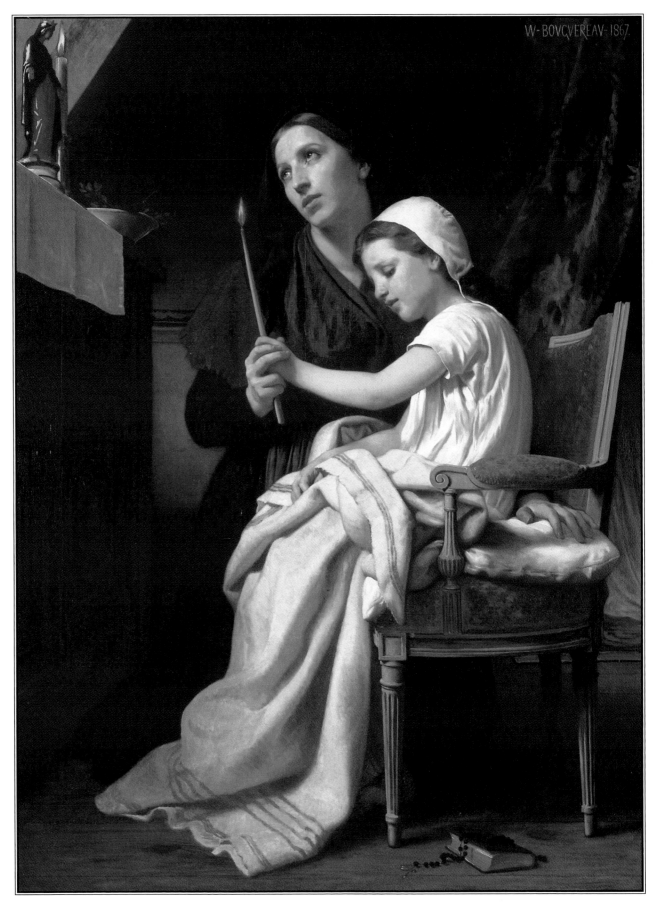

PLATE 22.

The Thank Offering, 1867

Oil on canvas, 147.2 x 107.0 cm (57¹⁵⁄₁₆ x 42⅛ in.). Gift of John G. Johnson for the W. P. Wilstach Collection, W.00-1-5. Philadelphia Museum of Art.

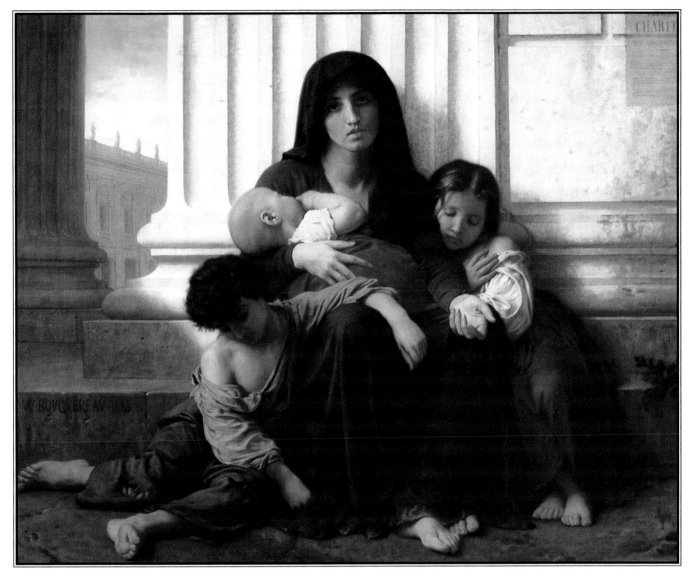

PLATE 23.

Indigent Family (Charity), 1865

Oil on canvas. Birmingham Museums and Art Gallery.

Paris. That the group rises only a little above the base of the engaged corner pilaster intimates their small size in relation to the structure towering above. This painting may carry an overt social message. The poster on the wall, at upper right, announces a lecture on the theme of charity by Père Lacordaire, whose lectures coalesced a revival of belief or, in Linda Whiteley's words, a "sentimental aspiration towards belief." Durand-Ruel wrote in his memoirs that, so far as he could remember, he attended every one of Lacordaire's lectures at Notre-Dame. It is likely that Durand-Ruel owned Bouguereau's picture, and it is equally likely that Bouguereau himself shared the simple faith Lacordaire espoused. The pyramidal group of mother and children under the poster offers a neat twist to an established image. Roman Charity as a type had for centuries represented selflessness and bounty. *Indigent Family* keeps the form but reverses the meaning: instead of symbolizing a social good, the figures here illustrate a social need. Bouguereau did only a few such pictures. His popularity lay in other areas.

MOTHERS AND CHILDREN

Images of mothers and children strike a deep chord than runs through many cultures. From the creation myths of the Sumerians to African and pre-Columbian figures and the Venus of Willendorf—with their exaggerated breasts, hips, and thighs—to the Virgin Mary, mothers as generative forces have been revered for centuries. Bouguereau acknowledges this primal understanding of mothers by painting women and children in many guises, who, through their poses, settings, or clothes are removed enough from everyday experience to function as quasireligious images. *Fraternal Love* unambiguously approximates countless Italian Renaissance pictures of the Virgin with the Christ Child and the Infant John the Baptist. *First Caresses* (1866; Plate 24) is another variant on the Madonna and Child theme, but instead of pointing to the spiritual relationship that will develop between the two children, this one emphasizes the human side of the mother-child bond, one that had been just as exhaustively explored by Renaissance artists.

The nineteenth century was a time of social upheaval, much of it foreshadowed in the eighteenth. Forms of government were changing from monarchies to republics, ways of earning a living were changing with the introduction of machines and the flow of people from the countryside to the cities, centers of wealth and power were shifting from the aristocracy to the entrepreneurial class. Even the family unit itself was changing, as it was affected by these larger social and economic forces. Yet if the basic components of the family—husband/father, wife/mother, and children—did not alter materially, the perception of how these elements functioned together did change. *First Caresses*, *Temptation* (1880; Plate 25), and such variants as *The Elder Sister* (n.d.; Plate 26) and *The Shepherdess* (1873; Plate 27) all express ideas dating from the late eighteenth century that were set forth most convincingly in the writings of the philosopher Jean-Jacques Rousseau. Only in the eighteenth century were babies and small children regarded as something other than small, messy, noisy creatures who should be kept quiet and out of sight. Childhood began to be seen as a special stage of development, and the nurture of children within the happy family unit was thought to bring parents untold satisfactions. Rousseau's *Julie, or Nouvelle Heloïse* (1761) and especially *Emile, or a Treatise on Education* (1762) propagated this new, inclusive ideal of the happy family, and artists put the words into images. Images of mothers playing with children or family groups posed for a portrait in intimate bedroom or boudoir settings, evincing an informality uncommon in previous centuries, became commonplace in the late eighteenth century. At the center of the family was the wife and mother, whose happiness was thought to arise from her familial duties. If fulfilling her role as wife and mother was her highest goal, then the woman in *First Caresses* personifies domestic and personal bliss.

Bouguereau successfully rang the changes on the theme of motherhood, and many of the variants display unexpected inflections. Whereas *First Caresses* is set indoors, amid a tidy jumble of still-life ele-

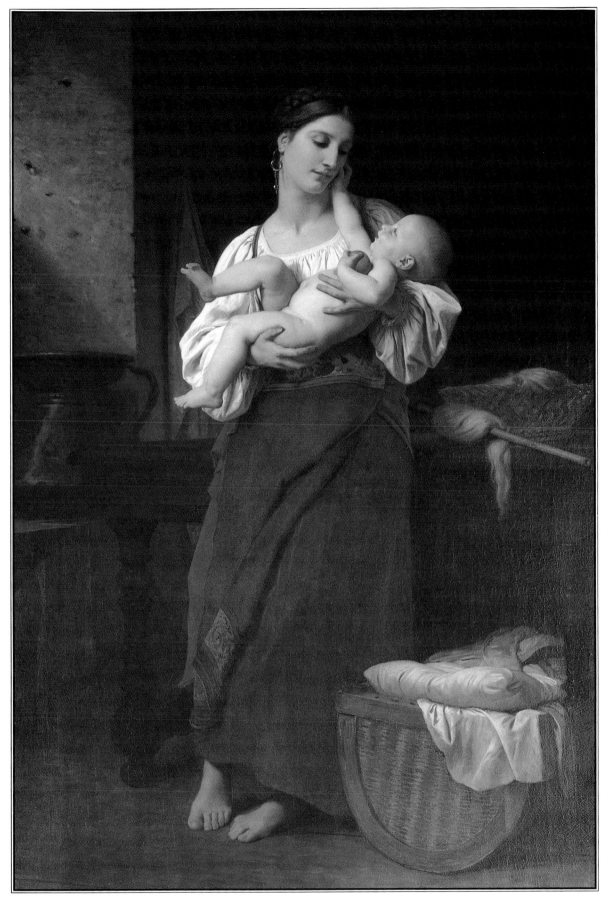

PLATE 24.

First Caresses, 1866

Oil on canvas, 190.0 x 127.5 cm (74¹³⁄₁₆ x 50³⁄₁₆ in.). Lyndhurst, a museum property of the National Trust for Historic Preservation.

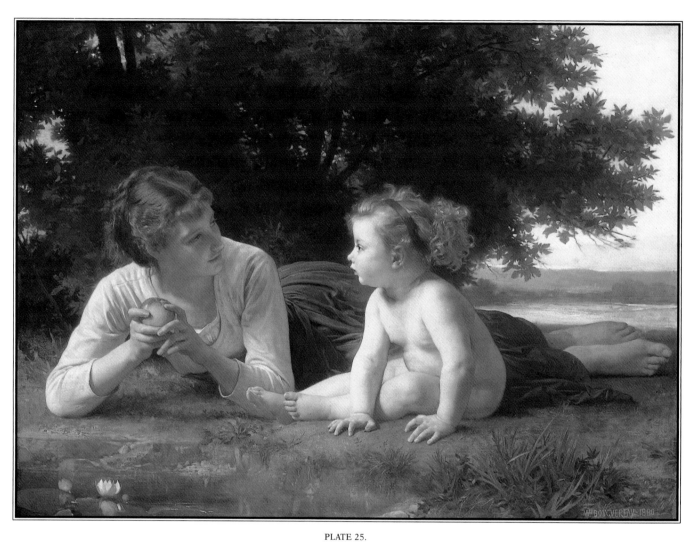

PLATE 25.

Temptation, 1880

Oil on canvas, 97 x 130 cm (38³⁄₁₆ x 51³⁄₁₆ in.). The Minneapolis Institute of Arts. The Putnam Dana McMillan Fund and the M. Knoedler Fund, 74.74.

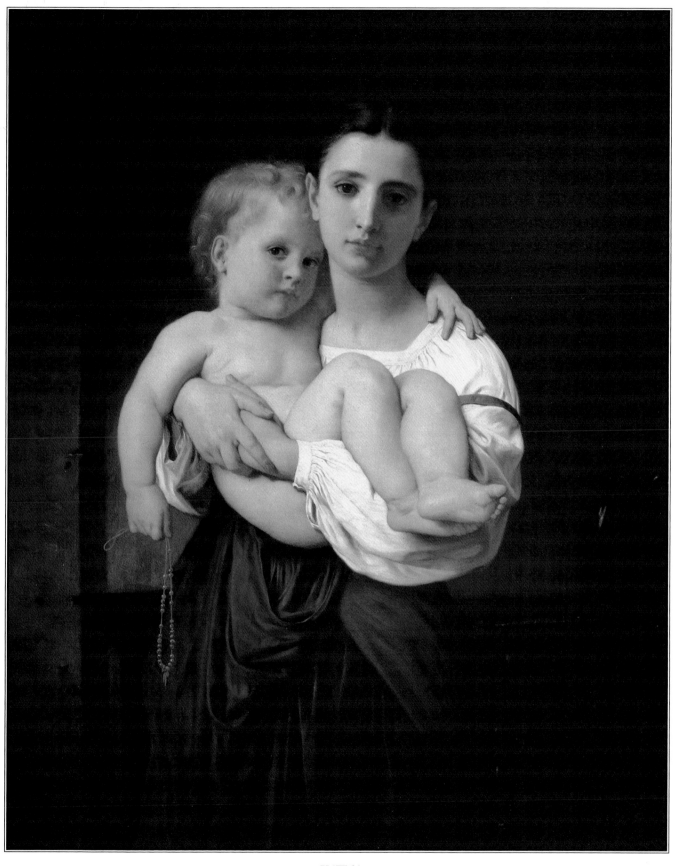

PLATE 26.

The Elder Sister

Oil on panel, 55.5 x 45.5 cm (21⅞ x 17¹⁵⁄₁₆ in.). The Brooklyn Museum 21.99. Bequest of William H. Herriman.

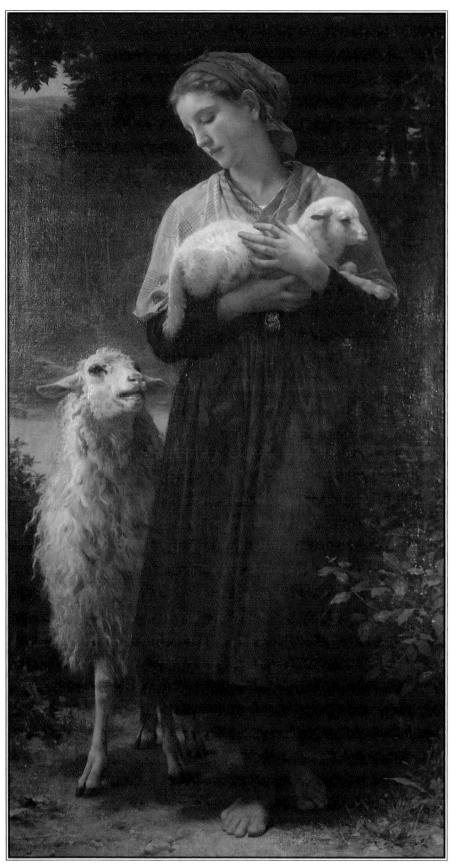

PLATE 27.

The Shepherdess, 1873

Oil on canvas, 165.1 x 87.63 cm (65 x 34½ in.).
Gift of Mrs. William S. Ginn, 1964.24. The Berkshire Museum, Pittsfield, Massachusetts.

ments Bouguereau used again and again (compare the copper jug here with the one in *The Secret*), the figures in *Temptation* are placed outdoors. Gone is the reliance on Renaissance models for the motif of playful Madonna and Child. Prototypes for the reclining mother are to be found instead, ironically, in depictions of Mary Magdalene, a prostitute whom Jesus saved from her sinfulness, alone in the wilderness. Despite the heritage of the formal pose, mother and child form a wholly believable group; one can sense, perhaps even feel, the bond between them.

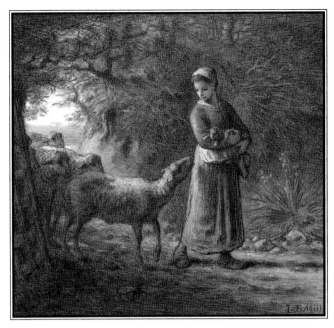

FIGURE 5.
Jean-François Millet (French, 1814–1875)
Newborn Lamb, 1866

Pastel and black conté crayon on paper, 40.4 x 47.1 cm (15⅞ x 18½ in.).
Gift of Quincy Adams Shaw through Quincy A. Shaw, Jr., and Mrs.
Marian Shaw Haughton. Museum of Fine Arts, Boston.

The same careful oversight and tenderness can be seen in *The Elder Sister*. Here the benefits accorded by Enlightenment authors to the happy mother of the eighteenth century are extended to older siblings, and the type reverts to that of the Madonna and Child, an idea underscored by the beads the child holds, which could function as a rosary. The figures are seemingly linked forever. Arms curve around to form not the perfect shape of a circle, but the generative shape of an egg. Crossed feet echo crossed hands in the middle of the canvas, contributing an area of visual interest second, but only just, to the contrasting heads pressed tenderly together. It is tempting to think that these figures, painted from paid, professional models, were in fact related. The elder sister has a faintly careworn look about her eyes; the baby rests naturally in her arms, wary of the viewer/painter but secure in the older girl's embrace.

The Shepherdess broadens the parameters of nurture. While it might be difficult for city dwellers to understand why the barefoot shepherdess needs to carry the little lamb, such a question need not distract from an appreciation of the suavity and grace of pose, the careful drawing, the sweetness of expression. The artist and author Earl Shinn, writing as Edward Strahan, in his survey of art collection of the United States in the 1870s, remarked: "Bouguereau, with his clean and waxen style, . . . has never attained greater elevation of quality than in his 'Nouveau-né,' or 'New-born Lamb,' a delicate subject of a sweet-faced shepherdess carrying a lamb, and turning to say soft, reassuring things to the ewe that trots apprehensively beside her." The shepherdess here is an icon of tenderness, functioning as a surrogate mother to the little lamb as she carries it to the warmth and safety of the barn. The tall, narrow proportions of the canvas (65 x 34½ inches) render the figure monumental; the girl is in fact life size. The colors used for her clothes—the soft red patterned scarf artfully tied around her head, the subtle yellow

plaid of her shawl, the purplish apron over a teal blue skirt—are at once sober and sophisticated. No browns, grays, or earth colors tie the girl figuratively to the soil. The shifting of her weight to her right leg automatically makes her body conform to the classical stance of *contrapposto*. Seemingly simple, the pose introduces complicated curves and emphases of body parts—hips, shoulders, legs, arms, and torso are all involved. This girl holding a baby lamb could as easily be a nude Venus.

Comparing Bouguereau's shepherdess with a similar scene by Millet (*Newborn Lamb* [1866; Figure 5]), while in a different medium—pastel—and on a wholly different scale, shows how Bouguereau has citified, or, at the least, taken the country out of his version. Millet's peasant does not pose; she has work to do and walks sturdily along. She does, however, take the time to look back at the ewe, a relatively scrawny creature, who follows her baby. In Millet's pastel the lamb is truly tiny—almost pathetic in its yearning for its mother—not the larger animal, old enough to resemble a big, fuzzy stuffed animal, cradled by Bouguereau's girl. Millet's shepherdess is stocky, rounded, and wears nondescript clothes. A telling difference, apart from the fact that Millet locates his figure in the specific context of the Norman countryside, evinced by the swinging gate in the hedgerow, is the girls' feet. Bouguereau's shepherdesses and mothers are almost always barefoot; Millet's wear *sabots*, the wooden shoes of the peasants. Bare feet can mean many things—poverty, a carefree life in a warm climate, humility. The bare feet of Bouguereau's figures underscore the fact that they are not real peasants, as Millet's were seen to be, so the urban viewer need in no way feel responsible for the peasants' hard lives. Bouguereau would have denied such an interpretation, insisting that he painted the human figure because it was the most beautiful subject to paint. Painting the figure well, meaning according to classical precepts, was the goal of the academic tradition of which he was a proud part. Thus, well-drawn and well-painted feet, notoriously difficult to render convincingly, can be seen as a mark of a highly skilled academic painter. Not interested in limning contemporary social concerns, Bouguereau focused all his attention on what he was good at—conveying sentiment in perfectly drawn figures.

PEASANTS, CHILDREN, AND OTHER OUTSIDERS

Peasants were an immensely popular subject in nineteenth-century French painting. City dwellers, from the time of Theocritus in the early third century B.C., have viewed people living in the country with a mixture of alarm and envy. In the pastoral tradition the peasant was seen to possess a simple and honest character, living an equally simple life, in tune with nature and apart from, even ignorant of, artifice. One form of peasant familiar to French society was the peasant from Italian opera and theater, first imported into French royal courts, where prettily dressed shepherds and shepherdesses found love among the sheepfolds and around the village well. Marie-Antoinette is probably the best-known eighteenth-century

PLATE 28.

The Young Shepherdess, 1885

Oil on canvas, mounted on board, 157.5 x 72.4 cm (62 x 28½ in.). San Diego Museum of Art
(Gift of Mr. and Mrs. Edwin S. Larsen, 1968:082).

PLATE 29.

Meditation, 1885

Oil on canvas, 86.4 x 132.1 cm (34 x 52 in.). Gift of Mrs. Rexford W. Barton. © Joslyn Art Museum, Omaha, Nebraska.

PLATE 30.

La tricoteuse (The Knitting Girl), 1869

Oil on canvas, 144.7 x 99.0 cm (57 x 39 in.). Bequest of Jessie Barton Christiancy. © Joslyn Art Museum, Omaha, Nebraska.

shepherdess, whose retreat to her make-believe hamlet at Versailles could be seen as a cruel mockery of the grinding lives of the true peasants. For life in the country, following the endless and inexorable needs of animals and crops, never was, and still is not, easy. Nevertheless, art making is a process of selection and, in many cases, wish fulfillment, and urban artists, working for urban audiences, for the most part chose to depict peasants as clean, happy, virtuous people leading uncomplicated lives, the presumed opposite to their own, perceived as crowded and hectic.

The image of the peasant changed somewhat in the mid-nineteenth century, when artists, notably Millet, actually lived in the countryside (he and his family lived in the village of Barbizon on the edge of the Forest of Fontainebleau, southeast of Paris) and were able to observe the lives of the country people as they lived it. This more direct view of peasant life introduced into the world of art was unsettling to the Parisian audiences, especially in the aftermath of the Revolution of 1848, an event that once again overthrew the monarchy and brought "the common man" to prominence. Much more comforting was the *retardataire* view of peasants as slightly exotic outsiders. Peasant status—that is, female peasant status, as Bouguereau painted female figures almost exclusively—was signaled by clothing and setting: simple white blouses, solid-colored overdresses, shawls that could be patterned with flowers or plaid, worn by invariably barefoot figures sitting, standing, or lying in a wooded glen, a field, or a grazing ground. For the nineteenth-century audience no further clues—such as sheep, hoes, plows, or hog troughs—were necessary, but they could be included for local color. Thus, Bouguereau's pictures of peasants and shepherdesses were vehicles for explorations of poses and expressions, ranging from slight curiosity (*The Young Shepherdess* [1885; Plate 28] to pensive contemplation (*Meditation* [1885; Plate 29]) to remorse (*The Broken Pitcher* [see Plate 38]), and from the single figure (*La tricoteuse* [Plate 30]) to pairs (*Breton Sister and Brother* [n.d.; Figure 6] to complex groups (*Return from the Harvest* [see Plate 35]).

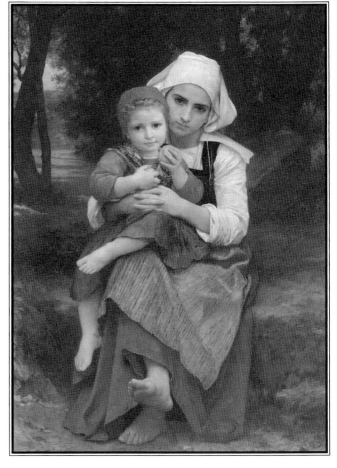

FIGURE 6.
Breton Brother and Sister
Oil on canvas, 129.3 x 89.2 cm (50⅞ x 35⅛ in.). The Metropolitan Museum of Art, Catharine Lorillard Wolfe Collection, Bequest of Catharine Lorillard Wolfe, 1887 (87.15.32).

In the hands of another artist, less concerned with surface finish and more concerned with social realities, the Italianate mother and her children in *Rest* (1879; Plate 31) would be understood to be destined for a fate similar to that of the *Indigent Family* (see Plate 23). Likewise, *The Bohemian* (1890; Plate 32) and *Les petites mendicantes* (The Little Beggar Girls) (1890; Plate 33) could be the results of an unjust economic system, in which children are forced to live by whatever means they can. Bouguereau and the well-to-do collectors who acquired his paintings preferred to see these children as picturesque outsiders, facts of daily life perhaps, but poignant rather than threatening. His intentions were well understood in his own day. René Ménard wrote in *Portfolio* in 1875:

> Rusticity is not with this painter an instinctive sentiment, and if he paints a patched petticoat he yet suggests an exquisitely clean figure: the naked feet he gives to his peasant-women seem to be made rather for elegant boots than for rude sabots; and, in a word, it is as if the princesses transformed into rustics by the magic wand in the fairy tales had come to be models for his pictures, rather than the fat-cheeked lasses whose skin is scorched by the sun and whose shoulders are accustomed to heavy burdens.

Before we in the late twentieth century rush to condemn what could be seen as Bouguereau's whitewashing, we would do well to remember the success in the 1870s of the American Winslow Homer's (1836–1910) pictures of American shepherdesses and field-workers, which also offered urban viewers a look at their countrymen while retaining a comfortable aesthetic distance, or of John George Brown's (1831–1913) pictures of young bootblacks and newspaperboys, reminders of social realities made palatable to the buying public.

But are Bouguereau's paintings as simple as that? As we have seen, *Indigent Family* carried with it a social and moral agenda. Perhaps pictures like *Rest*, *The Bohemian*, *Les petites mendicantes*, and *Little Marauders* (1872; Plate 34) could also be interpreted as statements of the artist's sense of the injustice of the society in which he lived. If his images are not as "realistic"—that is, as ready to depict bodies misshapen through work in threadbare surroundings—as those by artists such as Jean-François Raffaëlli (1850–1924) and François Bonvin (1817–1887), perhaps their message of inequality, because more subtle, was all the more potent. He could as easily have given his bohemian a different expression, but he chose a sad and wistful one.

In *Return from the Harvest* (1878; Plate 35), a simple ride on a donkey disguises several possible layers of interpretation. The present title was given to the painting by Earl Shinn; the artist called it *Promenade à âne* (Donkey Ride). With the woman and child on its back, the donkey puts the viewer in mind of images of the Flight into Egypt, and the two riders become a secularized Madonna and Child. The grape leaves wreathing the child's head and staff can refer either to the wine used in the sacrament of Holy Communion or to the harvest—or both. Bouguereau is unwilling here, as in so many paintings, to limit the interpretation.

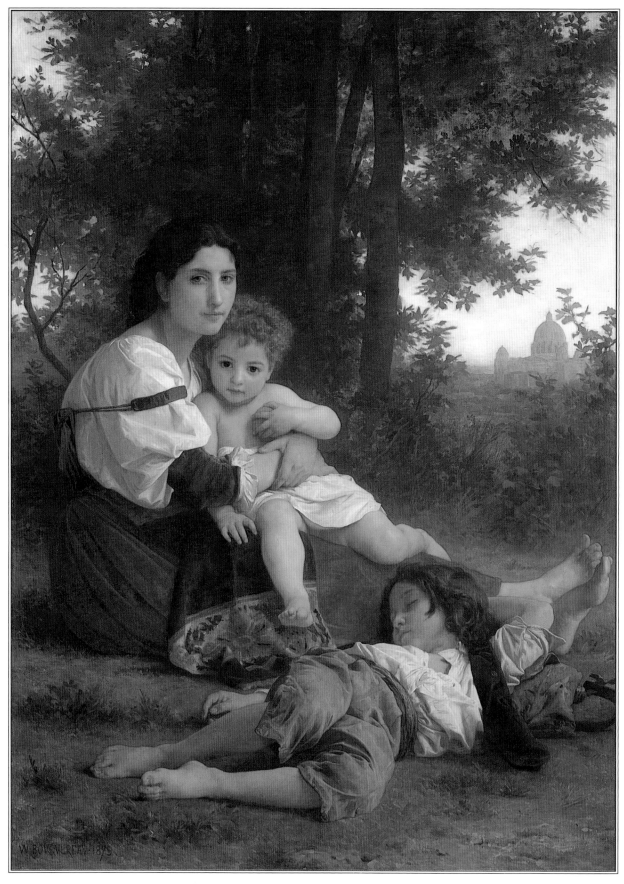

PLATE 31.

Rest, 1879

Oil on canvas, 164.5 x 117.5 cm (64¾ x 46¼ in.). © 1996 The Cleveland Museum of Art, Hinman B. Hurlbut Collection, 432.15.

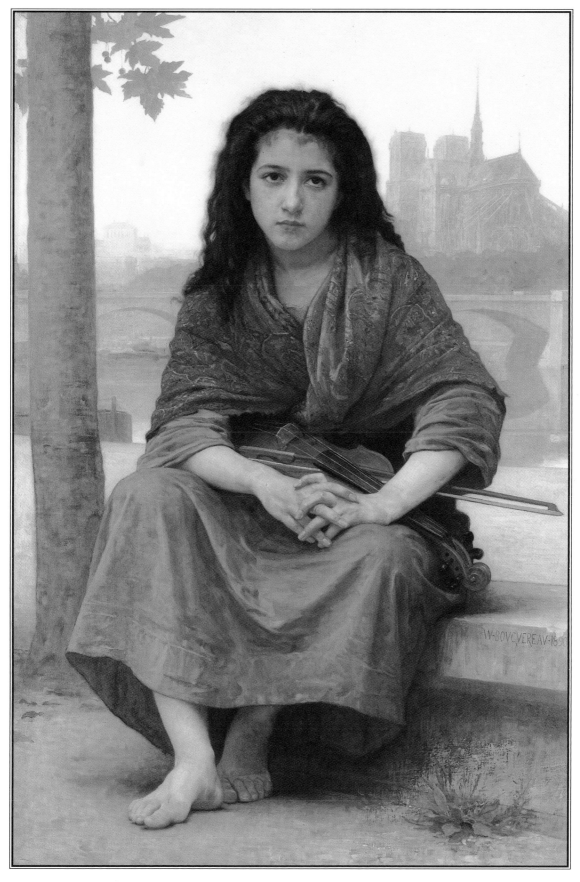

PLATE 32.

The Bohemian, 1890

Oil on canvas, 149.9 x 106.7 cm (59 x 42 in.). The Minneapolis Institute of Arts. The Christina N. and Swan J. Turnblad Memorial Fund, 74.33.

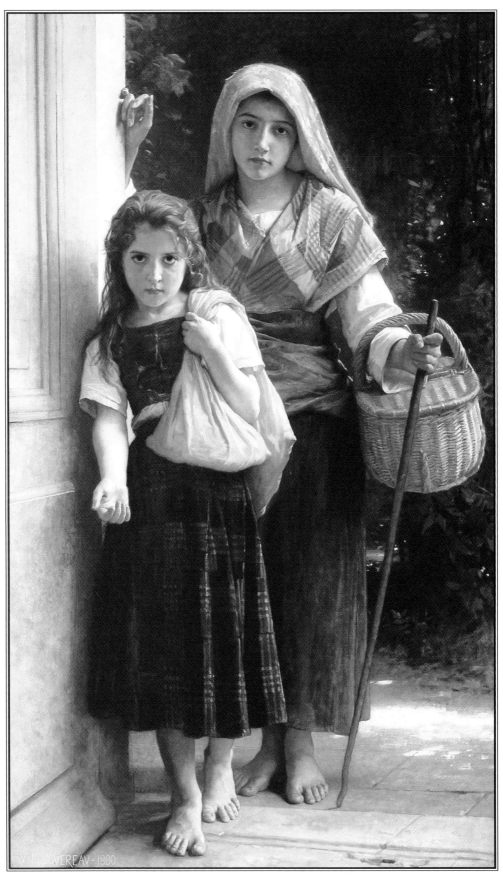

PLATE 33.

Les petites mendicantes (The Little Beggar Girls), 1890

Oil on canvas, 161.6 x 93.4 cm (63⅝ x 36¾ in.). Syracuse University Art Collection.

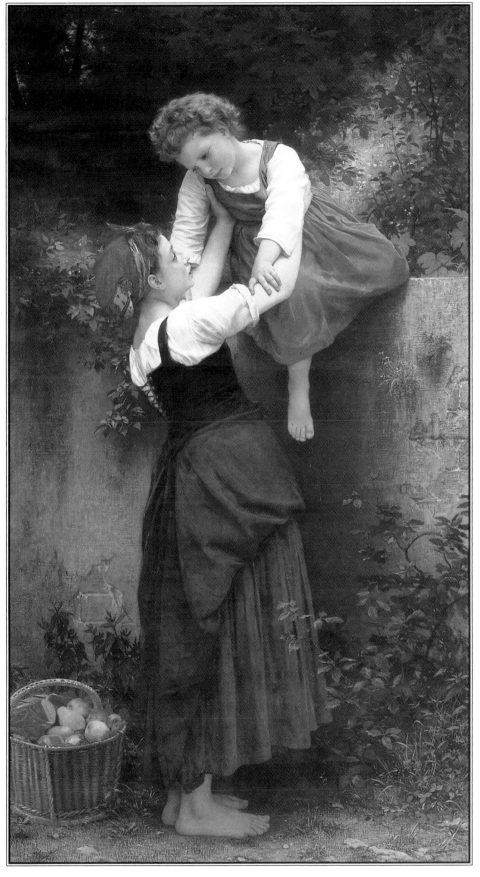

Little Marauders, 1872

Oil on canvas, 200.7 x 109.2 cm (79 x 43 in.). © 1996 Sotheby's, Inc.

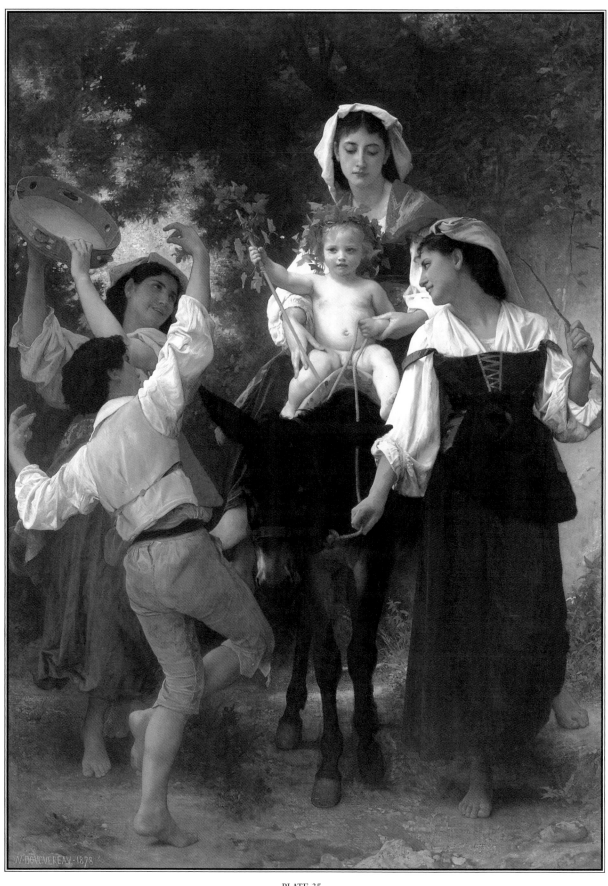

PLATE 35.

Return from the Harvest, 1878

Oil on canvas, 241.3 x 170.2 cm (95 x 67 in.). Cummer Museum of Art and Gardens, Jacksonville, Florida, AP 64.2.

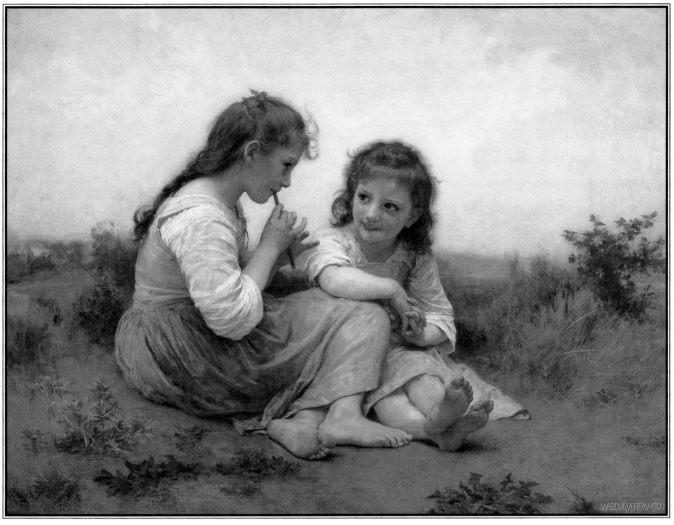

PLATE 36.
Childhood Idyll, 1900

Oil on canvas, 99.4 x 127.8 cm (39⅛ x 50⁵⁄₁₆ in.). Denver Art Museum. Gift of the Lawrence C. Phipps Foundation, 1958.115.

Children, apart from the adult world, may also be seen as the Other. The nineteenth century fairly deified the child. If the end of the eighteenth century glorified the role of mother, the nineteenth increasingly ceded to children their own preserves. Written literature for children developed into an independent genre, and children were understood to have lives of their own. *Childhood Idyll* (1900; Plate 36) shows two little girls in a field, enjoying the simple music of a pipe; *The Pet Bird* (1867; Plate 37) records the delight a small child takes in her pet. Bouguereau painted many such pictures, which present in a relatively straightforward manner an adult's view of uncomplicated, innocent childhood.

All was not so simple, however. *The Pet Bird* can be seen in the light of *Girl with Birds* (Figure 7) by the eighteenth-century French painter Jean-Baptiste Greuze (1725–1805). Here a young woman opens

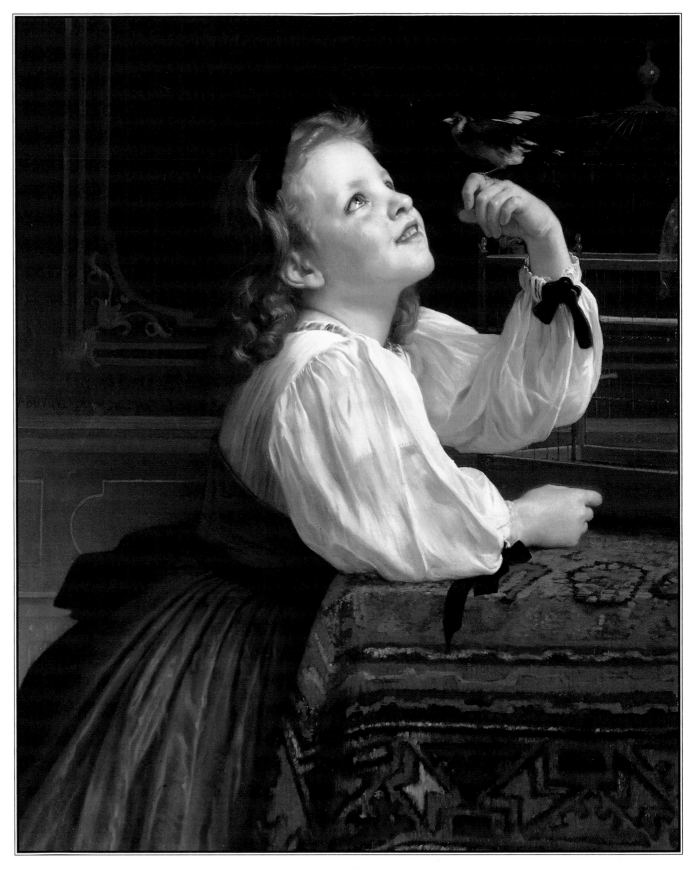

PLATE 37.

The Pet Bird, 1867

Oil on canvas, 81.9 x 66.0 cm (32¼ x 26 in.). © 1996 Sotheby's, Inc.

her filmy undergarment to admit a bird. Such imagery is clearly sexual. In many languages, variants on the word *bird* are euphemisms, and sometimes vulgar ones, for the male sexual organ. Bouguereau counted on his audience's familiarity with Greuze's image—this or similar ones were widely circulated through prints—to add a *frisson* when viewing his picture. *The Broken Pitcher* (1891; Plate 38) and *Rest in Harvest* (1865; Plate 39) likewise depict the blatantly sexualized child. A tradition existed in French art in which a single female peasant or shepherdess, seated in a pensive mood, signified love abandoned. In the iconography of the peasant, lovemaking in the countryside was free of the societal strictures that chafed young people in the city. Despite historical and documentary evidence to the contrary, peasants were thought to love in a pure and simple fashion. It followed, from an urban point of view, that a female peasant or shep-

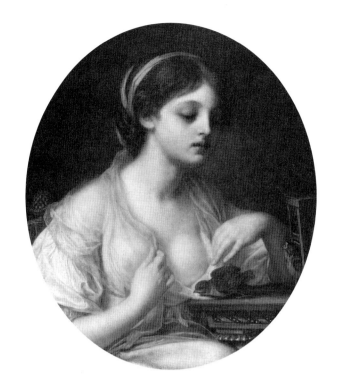

FIGURE 7.
Jean-Baptiste Greuze (French, 1725–1805)
Girl with Birds

Oil on canvas, 61.4 x 52.0 cm (24⅛ x 20½ in.) (oval). Timken Collection, © 1996 Board of Trustees, National Gallery of Art, Washington.

herdess depicted seated alone meant that she was waiting in the accustomed trysting place for the lover who would never appear. *The Broken Pitcher* also reaches back to the eighteenth century to do so, using a broken pitcher to signify lost virginity. It is again Greuze who popularized the imagery of the broken pitcher. The use of eighteenth-century themes guaranteed that nineteenth-century audiences would understand the story being told. But if eighteenth-century audiences could read the image of a girl with a broken pitcher as a story of virtue lost, Bouguereau gave his public the added clue in the form of the fountain's spigot at the upper left to leave no doubt as to the real agent of the girl's remorse.

Even more overt in its sexualizing of children on the cusp of adulthood, because the girl is conscious of her allure, is *Rest in Harvest*. When Jules Breton (1827–1906) or Millet painted peasants resting in the fields, they showed adults, worn to the bone from heavy work, sprawled in exhaustion. This lass has clearly seen no arduous labor, and her direct gaze establishes a connection with the viewer that Millet's peasants do not have the energy for or any interest in. This gaze from the picture out to the viewer's space is an unsettling device. It is a convention in portraits, of course, in which the sitter straightforwardly presents his or her person for public inspection. In history paintings and genre scenes as well, there is often a figure looking out of the picture at the viewer, beckoning us into the fictive space, but

these figures are usually placed in a corner and are but one of many in the scene. In a number of Bouguereau's works, however, the figure staring out at us is the only one depicted, much in the manner of Francisco de Goya's (1746–1828) *Naked Maja* (c. 1800, Museo del Prado, Madrid), whose bold stare and nakedness were locked up in the Madrid Academy in the nineteenth century. Thus, in the case of *The Broken Pitcher*, it is impossible, at first, to look anywhere other than into the girl's large, dark eyes. Only later, when we notice the broken pitcher and the spigot, do we understand the pleading, embarrassed expression on the girl's face. Conversely, the girl looking out from *Rest in Harvest* leaves no doubt as to her willingness to cast aside the flower of her maidenhood, clasped so loosely in her hand.

Such images as *Rest in Harvest* or *Child at Bath* (1886; Plate 40) set off alarm bells in the late twentieth century, with our awareness of child abuse in its many forms. It is important when looking at these pictures and others by Bouguereau, his contemporaries, and precursors back to antiquity—in which children, nude or clothed, are depicted in what to our eyes are provocative poses and situations—that we remember we are looking at art, a complex system of symbols and conventions that only rarely reflects life as it is lived. In antiquity fat little babies painted on vases and in murals played at all sorts of grown-up games, from assisting at romantic assignations to forging iron or waging mock battles. Artists in the Renaissance revived the babies-as-adults theme, and the tradition continued.

What is different about Bouguereau's interpretation is the frankness of the presentation. The smooth technique almost fools us into thinking we are looking at something real, or if not real, photographic. Many artists of the nineteenth century used photographs to help plan their paintings; Bouguereau, despite the appearance of his paintings, did not. Compared to nudes painted by other nineteenth-century artists, for example, Bouguereau's are alarmingly present. His superb technique allowed him to replicate the textures of various materials, so that hair looks different from fur, gauzy fabric different from heavier, coarser cloth, and flesh is sensuously itself in distinction to whatever other materials are around it. Whereas Renoir, for instance, did not conceal the way his nudes were created—increasingly after 1881 he put paint on canvas in easily discernible ways—this was not the case with Bouguereau. In addition, Bouguereau differentiates between foreground—the figure—and the background. Where the Impressionists were concerned to depict figures in a landscape as an integral visual whole, and achieved this by using the same broken-brushwork technique throughout, Bouguereau treats the backgrounds almost as if they were theatrical backdrops, whose broadly brushed, often indeterminate forms simply set the scene. This effect is similar to that of nineteenth-century photographs, in which, because of the rudimentary state of the technology, both foreground and background could not simultaneously be in focus. In Bouguereau's paintings the only element of interest is the figure, and when that figure is a seminaked child, whose direct gaze meets ours, we grow uneasy. But Bouguereau's intended audience did not. If they acknowledged the undercurrent of sexuality, either they repressed it and enjoyed the superb painting technique, or they admitted an appeal in a way

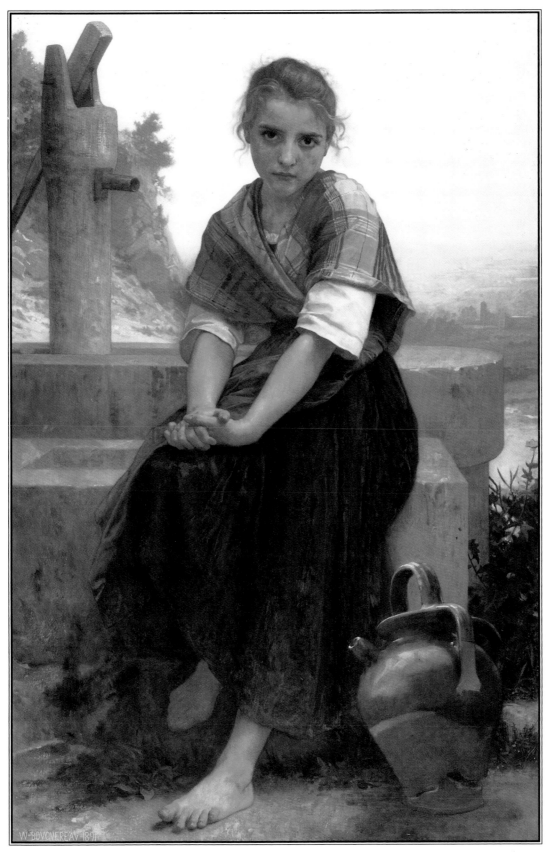

PLATE 38.

The Broken Pitcher, 1891

Oil on canvas, 133.0 x 85.5 cm (52⅜ x 33⅝ in.). Fine Arts Museums of San Francisco. Gift of M. H. de Young, 53162.

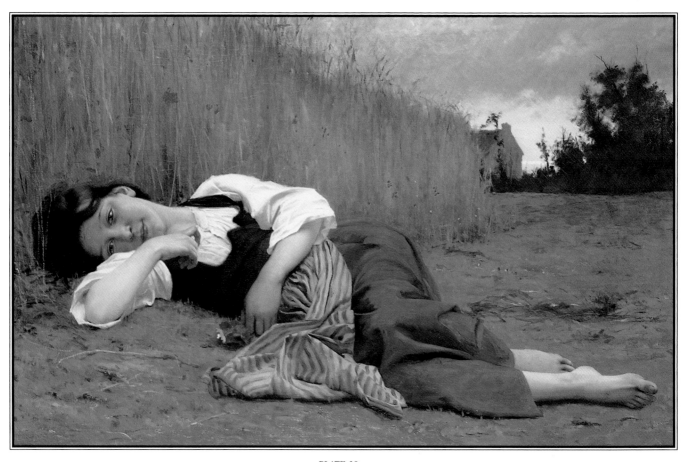

PLATE 39.

Rest in Harvest, 1865

Oil on canvas, 81.3 x 147.3 cm (32 x 58 in.). The Philbrook Museum of Art, Tulsa, Oklahoma. Gift of Laura A. Clubb, 47.8.32.

perhaps more honest than our contemporary mores permit. Think of Charles Dodgson (Lewis Carroll), who was able to photograph little girls in the nude only because the parents of the girls allowed him to do so. An appreciation of the fullness of childhood, which encompasses both innocence and sexuality, informs both Dodgson's photographs and Bouguereau's paintings.

THE MADONNA AND CHILD

Children are a leitmotif in Bouguereau's art, and an important subset of that group is the sacralized child, the Infant Christ. And the honesty Bouguereau evidenced in representing the sensuosity of the flesh of children in general is at work in paintings of the Madonna and Child, as well.

Bouguereau had already explored the subject of the secularized Madonna and Child in his 1851 *Fraternal Love* (see Plate 17). When he turned to more traditional depictions of the Madonna, such as *Madonna and Child with St. John the Baptist* (1882; Plate 41), *Charity* (1878; Plate 42), or *Virgin and Child* (1888; Plate 43), the composition expands to include a formal setting. A throne derived

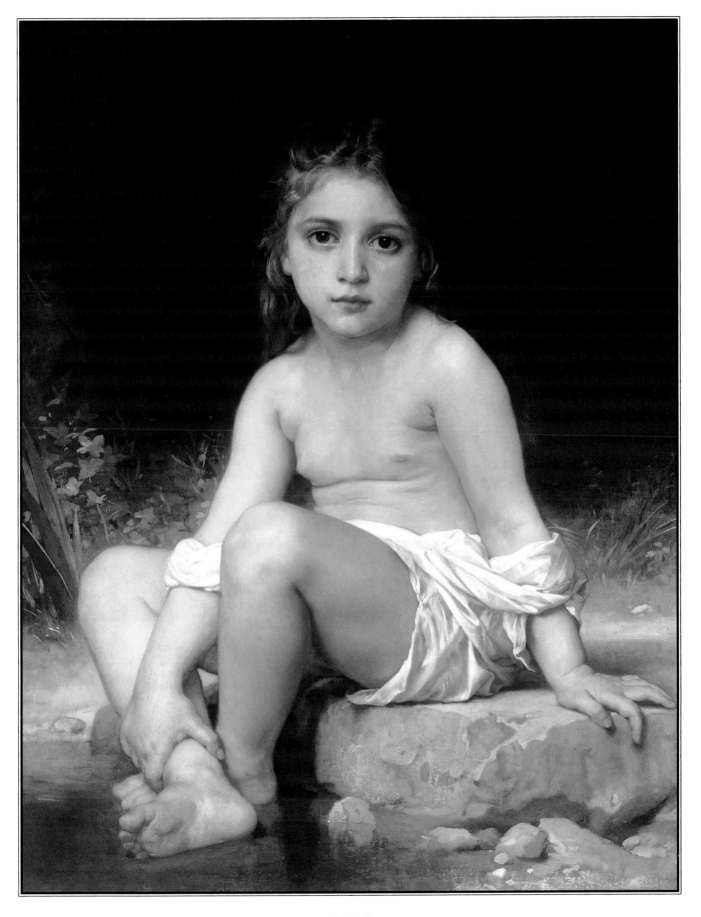

PLATE 40.

Child at Bath, 1886

Oil on canvas, 83.5 x 61.6 cm (32⅞ x 24¼ in.). Henry Art Gallery, University of Washington, Horace C. Henry Collection, 26.12.

from Renaissance paintings fills the space or, in the case of *Charity*, architectural elements are put together to form a thronelike structure. Bouguereau self-consciously used these art-historical references to lend his works a sense of tradition, to align his art with that of the great masters of the past. Prototypes for the hieratic female figure of Charity—source of succor and comfort, surrounded by children to whom she ministers—can be seen in the work of Andrea del Sarto (1486–1530). And the tender interaction of the Infant Saint John and the eerily prescient pose of the Christ Child, prefiguring his crucifixion, is not unprecedented in art. What is striking about these pictures is the balance the artist achieves between immobile, static forms and the richness of surface detail, texture, and color. Bouguereau gives the viewer a visual playground, in which the eye is invited to enter and linger over perfectly rendered polished marble and porphyry, sumptuous fabrics embellished with gold, velvets and brocades, fine carpets, finer gauze, rough fur. He is careful to distinguish between the silken golden hair of the Infant Christ and the coarser, but still babyish, hair of the Infant John. The overall impression is one of linear form, Bouguereau's solid draftsmanship being the armature on which these colors and textures are hung, yet within this matrix he takes care to differentiate colors and textures, with the result that the eye is happy to wander throughout the canvas, finding endless examples of painterly finesse.

Such mastery is certainly an homage to the subject, but it is also somewhat unsettling. There is a disjunction, as the art historian and critic Robert Rosenblum has pointed out, between technique and subject matter in late-nineteenth-century paintings of religious and mythological scenes. The nineteenth century's interest in empirical fact, evidenced by the explosion of learning about the natural world through observation, is reflected in the descriptive rendering of objects and figures so that they appear hauntingly lifelike. Bouguereau always said that he painted only the real: "In spite of all that is written to the contrary, an artist only reproduces what he finds in nature—to know how to see and how to seize what one sees—there is all the secret of the imagination." Bouguereau used models and had access to the treasures of past art, costumes, architectural members, and decorative arts gathered in Paris. He put his paintings together by assembling these disparate elements, each taken from the real world. And so he truly felt that his art was not an act of imagination but one of transcribing the world as he saw it. Yet there is a hallucinatory aspect to paintings treating sacred subject matter, because while the models were real people, they were playing parts that were far removed from the nineteenth century. The nineteenth-century French artist Gustave Courbet (1819–1877) equally claimed to paint only what was real and scoffed at the suggestion that it was possible to paint an angel. He could not do so, he insisted, because he had never seen one. Bouguereau did not define reality in the same way that Courbet did, and so he could paint *Song of the Angels* (1881; Plate 44). Striking in this painting is the casualness of the Virgin's pose, the artlessness of the Child. The angels playing a lullaby for the Christ Child are surely present, rendered with the smooth brushwork that

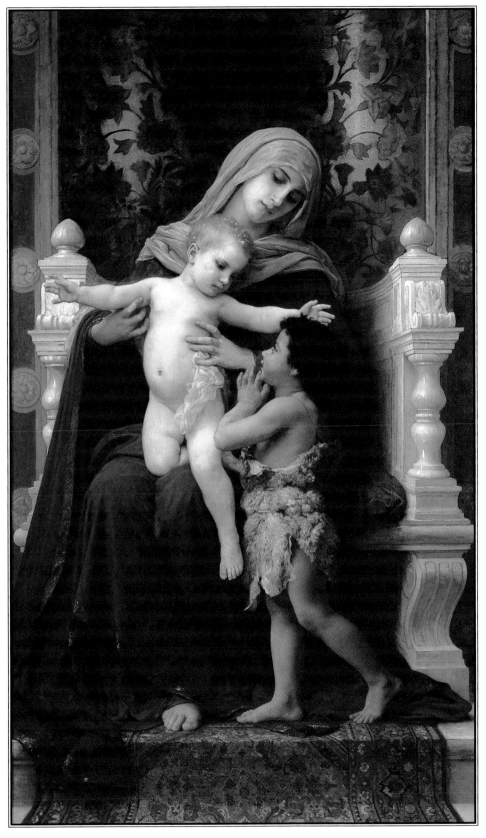

PLATE 41.

Madonna and Child with St. John the Baptist, 1882

Oil on canvas, 190.5 x 110.8 cm (75 x 43⅝ in.). Gift of Louis V. Keeler (Class of 1911) and Mrs. Keeler, 60.082.
Herbert F. Johnson Museum of Art, Cornell University, Ithaca, New York.

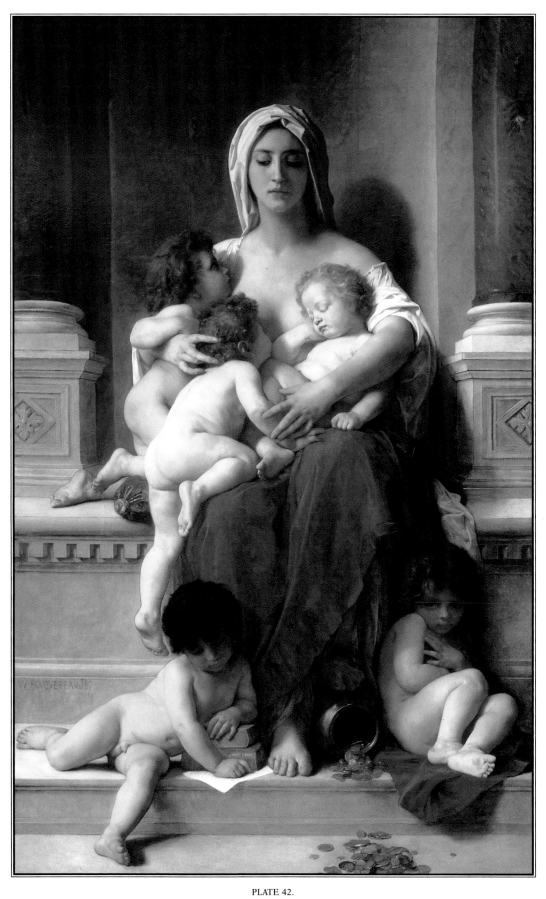

PLATE 42.

Charity, 1878

Oil on canvas, 193.0 x 115.6 cm (76 x 45½ in.). Smith College Museum of Art, Northampton, Massachusetts. Anonymous extended loan.

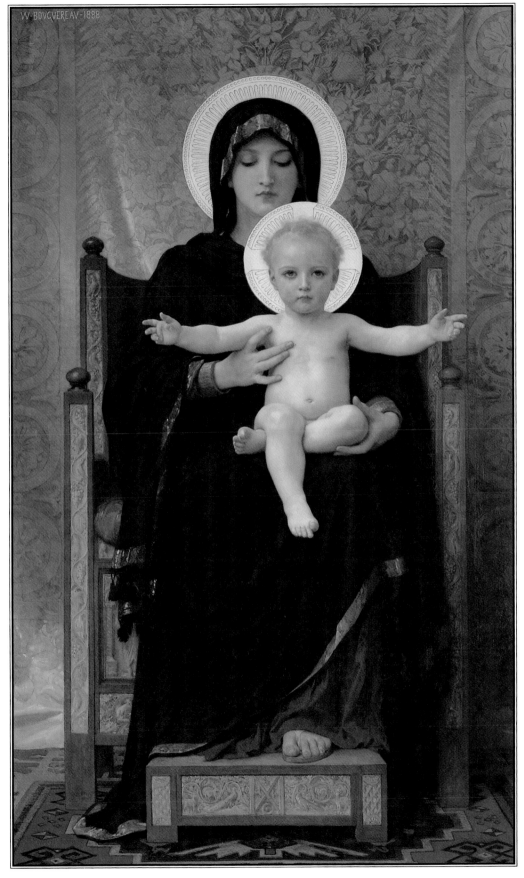

PLATE 43.

Virgin and Child, 1888

Oil on canvas, 176.5 x 103.0 cm (69½ x 40⅞₆ in.). Art Gallery of South Australia, Adelaide. Elder Bequest Fund 1899.

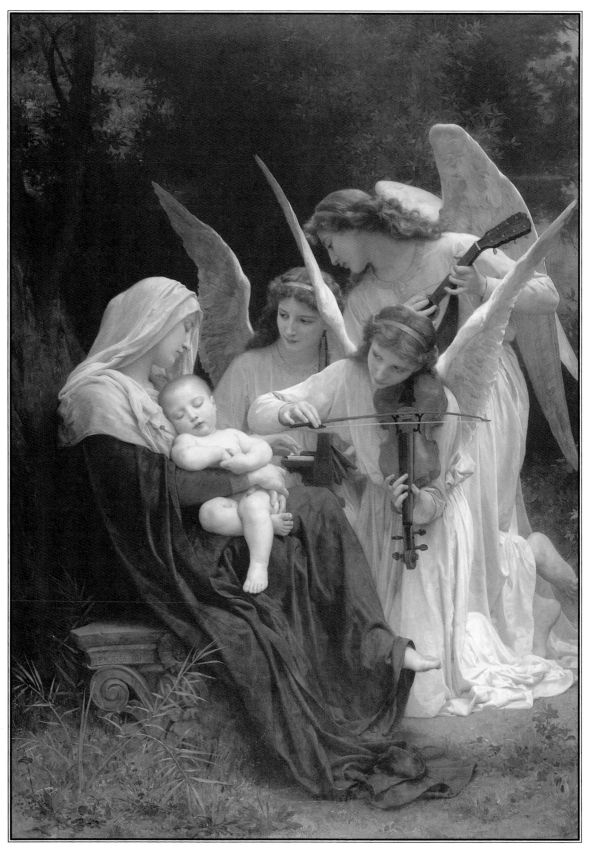

PLATE 44.

Song of the Angels, 1881

Oil on canvas, 213.4 x 152.4 cm (84 x 60 in.). Museum at Forest Lawn Memorial-Park, Glendale, California.
Courtesy Forest Lawn Cemetery Association.

erases all trace of the painter's hand. If there ever were a photograph of angels, it might well look like this.

In his own day, Bouguereau's technique was often described, and criticized, as being sculptural. Earl Shinn, who had gone to Paris to study, wrote of *Charity* and a replica of it and found something positive to say about this sculptural quality. "Mr. Drexel's [J. W. Drexel, of New York, owned *Charity* in the 1870s] largest object is Bouguereau's serene, tranquil, gracious picture of 'Charity' (5 x 9 feet [Shinn exaggerated the painting's size]) painted in 1878, and one of the most highly finished pieces of sculpture with the brush ever achieved even by this *magister emeritus* of elegance and grace." Of the replica with the figures placed in a landscape, Shinn wrote: "Bouguereau is often reproached for the smoothness and polish of his style, for the even and regular finish which makes perfection a defect. But with a theme like this the adamantine surface becomes an assistant of the impression: it makes 'Charity' seem invulnerable, as she should be."

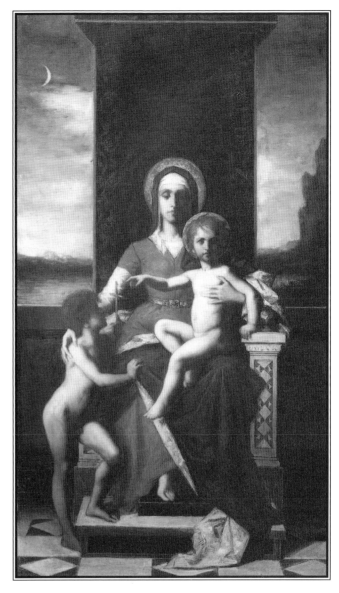

FIGURE 8.
Ferdinand Humbert (French, 1842–1934)
The Virgin and Child with St. John the Baptist, c. 1874
Oil on canvas, 81.3 x 45.7 cm (32 x 18 in.). High Museum of Art, Atlanta, Georgia, 1982.22.

How different Bouguereau's treatment of the subject is from that of his contemporary Ferdinand Humbert (1842–1934). Humbert's *Virgin and Child with St, John the Baptist* (c. 1874; Figure 8) abstracts the figures, makes them less lifelike than those in Bouguereau's paintings. The throne placed before a landscape indicates that the picture is set in an ideal realm. Although the painting reproduced here is a sketch, and therefore does not display the high finish of Humbert's completed work (cathedral, Metz), one can nonetheless discern the gap between Humbert's idealism and Bouguereau's idealized naturalism. Each artist derived his picture from Italian Renaissance prototypes; what distinguishes the nineteenth-century versions is the artists' technique.

EXHIBITION STRATEGIES

Bouguereau did not paint scenes of the Madonna and Child and secularized versions of it or of children or shepherdesses to the exclusion of all other themes. As mentioned briefly in Chapter One, he carefully chose the pictures he sent to the Salon, which remained the primary venue for public exhibition of history paintings. And, despite the well-publicized schism between Monet and his colleagues and the establishment artists such as Bouguereau, Monet and Renoir also submitted pictures to the Salon jury, both at the beginning of their careers and later. Renoir wrote to his dealer, the same Durand-Ruel whom Bouguereau left for Goupil:

> I am going to try and explain to you why I exhibit at the Salon. In Paris there are scarcely fifteen collectors capable of liking a painter without the backing of the Salon. And there are another eighty thousand who won't buy so much as a postcard unless the painter exhibits there. That's why every year [Renoir was writing in 1881] I send two portraits, however small. . . . This entry is entirely of a commercial nature. Anyway, it's like some medicine—if it does you no good, it won't do you any harm.

If two modest portraits were enough to keep one's name before the public (and in 1881 over 300,000 people went to the Salon, which was open for two months), then larger, more ambitious pictures would be even more advantageous to the artist's public image.

Bouguereau's range of subject matter was wide. His works included portraits, genre pictures, mythological subjects, allegories, and religious scenes. Bouguereau frequently showed in one exhibition pictures that demonstrated the different moods he was capable of creating. In 1880, for instance, he showed *The Flagellation of Christ* (1880; Plate 45) and *Young Girl Defending Herself against Eros* (1880; Plate 46). *The Flagellation* is a huge painting, almost thirteen feet high and nine feet wide. With its over-life-size figures and stark subject, it must have been intended to shock. Such a large painting, if not a commissioned work, would have been impossible to sell, and the artist gave it the following year to the Society of Friends of the Arts in La Rochelle, his hometown. Deciding to paint a work like this and then to give it away says several things about Bouguereau and how he regarded his art. By 1880 he was well established and could, financially, afford the considerable time required to execute a work of this scale without being paid for it. This alone is an index of his secure position in the art world and of his self-confidence. But he did not send it directly to its destination in provincial La Rochelle, because it was still important for him to exhibit the canvas in Paris.

The subject of *The Flagellation*—torture—is disturbing on its own account. Its huge scale would have made it difficult to avoid in any room in which it was hung. Yet Bouguereau includes another

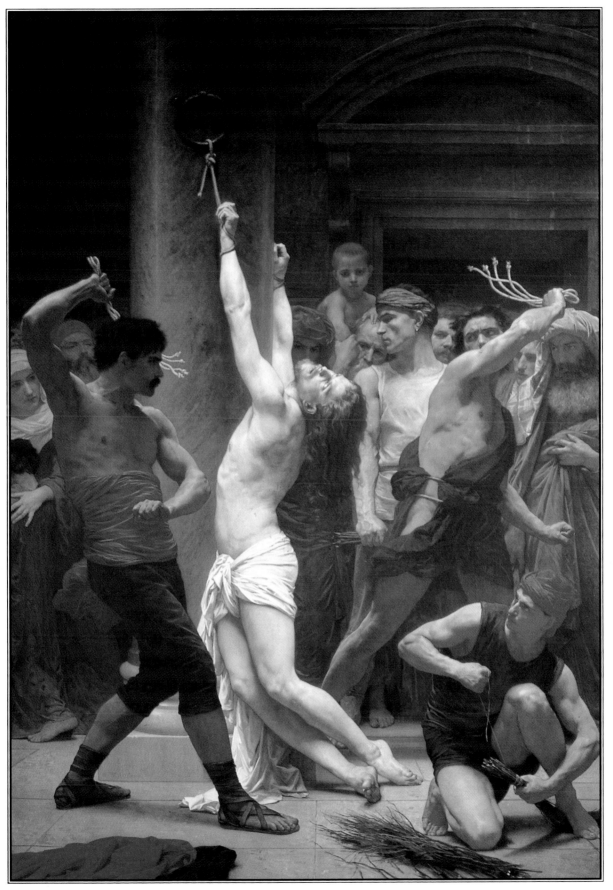

PLATE 45.

The Flagellation of Christ, 1880

Oil on canvas, 390 x 210 cm (153⁹⁄₁₆ x 82¹¹⁄₁₆ in.). Cathedral of La Rochelle. Photograph by Eric Dessert,
© 1985 Inventaire Générale S.P.A.D.E.M.

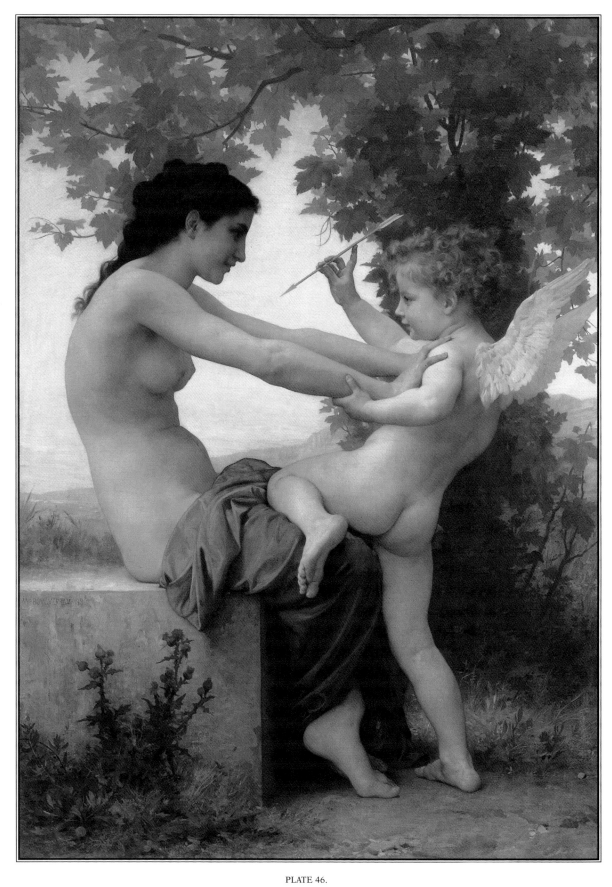

PLATE 46.

Young Girl Defending Herself against Eros, 1880

Oil on canvas, 160.8 x 114.0 cm (63⁵⁄₁₆ x 44⁷⁄₈ in.). In the collection of the University of North Carolina at Wilmington, currently on loan to the North Carolina Museum of Art. Photograph by Jerry Blow.

element in the picture to create additional uneasiness in the viewer: a crowd of curious onlookers. Interested but uninvolved, they are unlike similar crowds in Northern Renaissance works. There, the men (and they are almost all men in earlier depictions) are transformed by the act of public torture into a leering, snarling mob. Here, by contrast, the crowd simply watches. Only the young child at the left turns away from the horror; its mother shows no similar revulsion. One wonders if the artist is commenting on his own society.

How very different, therefore, is the picture that Bouguereau showed together with *The Flagellation*, *Young Girl Defending Herself against Eros*. Both pictures feature the nude body, but to opposite expressive effect. Bouguereau's draftsmanship is so refined here that he could differentiate the smooth yet voluptuous curves of the young woman's body and the lines that define the pudginess of the Cupid. In the Western tradition, Cupids, generalized manifestations in Roman mythology of the Greek deity Eros, numbered among Venus's retinue. Their arrows caused hearts to become inflamed with amorous passion. Not everyone was anxious to embark on the thorny path of love, or so Bouguereau's image implies. The young woman's resistance is surely but token. Having resolved the struggle in his own mind, the viewer can be content with admiring the interconnecting lines of limbs, the difficulty of Cupid's pose successfully rendered, and the seemingly real wings sprouting from Cupid's shoulders.

Bouguereau exhibited such contrasts in mood throughout his career. For example, *Fraternal Love* appeared at the Universal Exposition of 1855 along with a portrait, a head of a bacchante, and *Le triomphe du martyre*. *Le jour des morts*, another portrait, and *Wounded Cupid* (presumably showing the little one pricked by one of his own arrows and crying) were shown at the Salon of 1859. And so it went, including such pairings, or non-pairings, as *Le ravissement de Psyché* (The Abduction of Psyche) (1895; see Plate 60) and a self-portrait, which were exhibited in the Salon of 1895. One interpretation of this eclecticism would be opportunism, Bouguereau's painting diverse subjects in an attempt to have a hand in every available market. This was undoubtedly partially the case. Yet from all accounts Bouguereau was a sincere man, and there is no denying his gift in faithfully portraying the childishness of children, the comeliness of young women, or the muscular physiques of the few men who figure in his mature works.

It is true that women and children predominate in Bouguereau's works, a prevalence that lays his work open to twentieth-century charges of sexism, of objectifying the female body for visual consumption by the predominantly male audience. He felt only that he was carrying on the tradition of classical art, in which the human body was the supreme vehicle for meaning. Trying to see Bouguereau in the context of his own day may not satisfy our late-twentieth-century desire for fair treatment for all, but it helps explain why his pictures look the way they do.

RELIGIOUS WORKS

Religious imagery was a constant theme in Bouguereau's oeuvre. At times he used religious themes to make public his private feelings of loss and anguish. *Pietà* (1876; Plate 47) and *Vierge consolatrice* (Virgin of Consolation) (1877; Plate 48) memorialize the deaths first, of his son Georges, at the age of sixteen in July 1875, and second, of his wife, Nelly, and eight-month-old son, William-Maurice, only months apart in the spring of 1877. Bouguereau translated his experience into Christian terms. When he showed *Pietà* at the Salon of 1876, critics aptly likened the group of the Virgin and Christ to Michelangelo's marble *Pietà*, now in Saint Peter's in Rome. Michelangelo's group, surely the inspiration for Bouguereau's image and which Bouguereau might have seen during the years he was in Rome, had become the archetype for this subject and, by extension, a mother's grief at the loss of a child. By the 1870s photographs of famous works of art had become widely available, affording closer fidelity to the original. Bouguereau purchased one of these and hung it up in his studio (see Figure 9). *Vierge consolatrice*, reputedly the artist's most famous painting, places the Virgin as mediator between the mother's grief and the heavens. The deaths of so many people in his family, in such a short time, coalesce into these strong forms, monumentalized by the great mass of robes. We can assume that Bouguereau found solace in this image of intercession; its popularity likewise testifies to the consoling powers of Catholicism.

If *A Soul Brought to Heaven* (1878; Plate 49) was not conceived as a tribute to a specific family member, it was nonetheless painted while the artist was still in mourning. It came to function as a memorial, however, when the dealer Goupil sold it the very day he received it from the artist to a certain Edouard Werlé, who gave it to his

FIGURE 9.

Bouguereau in his studio, 1890/1891
Bibliothèque Nationale de France.

74

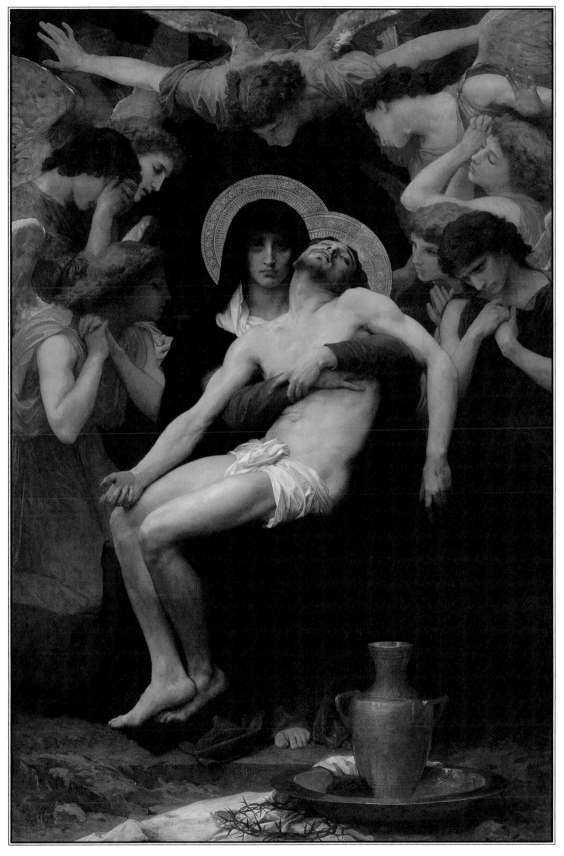

PLATE 47.

Pietà, 1876

Private collection. Photograph courtesy The Montreal Museum of Fine Arts.

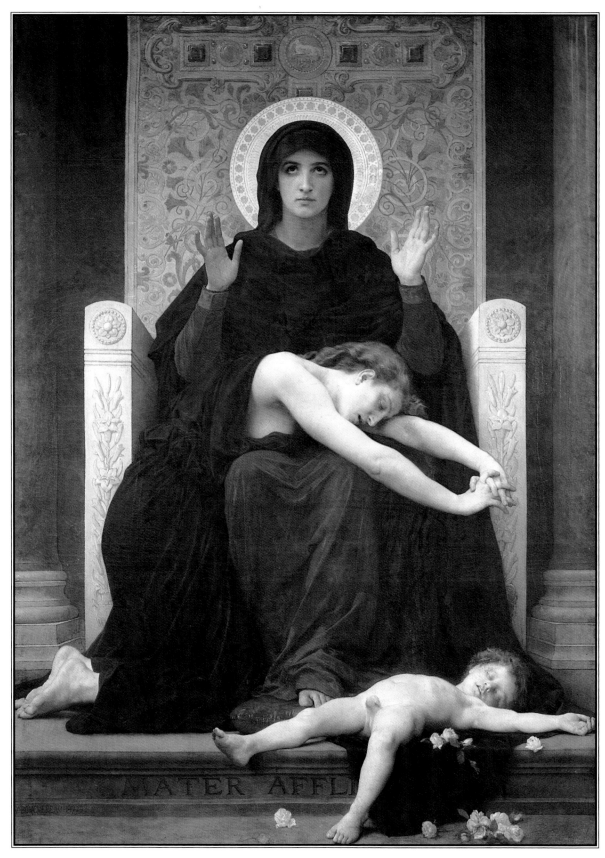

PLATE 48.

Vierge consolatrice (Virgin of Consolation), 1877

Les Musées de la Ville de Strasbourg

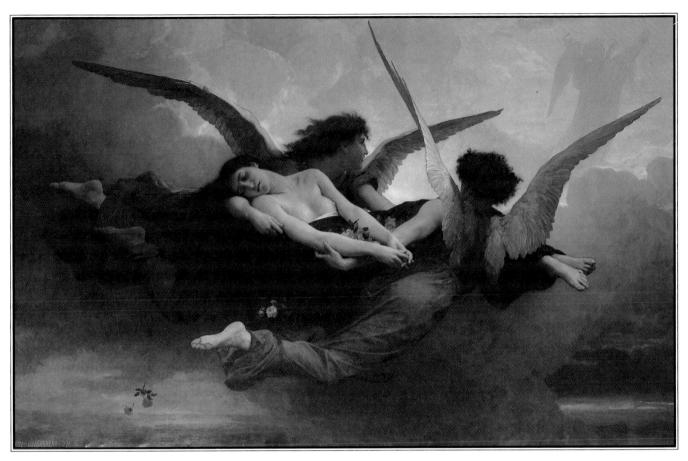

PLATE 49.

A Soul Brought to Heaven, 1878

Oil on canvas, 180 x 275 cm (70⅞ x 108¼ in.). Musée du Périgord.

daughter in memory of his granddaughter, who had died that year at the age of eighteen. The body of the dead woman has real weight. Her shoulders and hips, turned in opposing directions, make her body torque, and her arms fall to the side, where they must be supported by the angels. Flowers laid in tribute on her body spill over her arms and fall, victims of the rush of air streaming over her form. A comparison of this body to that of Zenobia (see Plate 2) shows how Bouguereau's style had developed over the years. Zenobia's body, livid with cold and exposure, nonetheless appears sculptural, even marmoreal, whereas this soul is vividly personified in a human form. It is, in addition, an oddly comforting image. Not specifically tied to any one set of religious beliefs (many belief systems reserve a place for angels), it conveys a tenderness, an attention to the individual, that counteracts the deep human apprehension of what may happen to us after death.

HISTORY PAINTING AND CLASSICIZING WORKS

The Bible, Christian teachings, and Greek myths were sources dear to Bouguereau his whole life. When he first arrived in Paris, in 1848, he applied himself to serious study. He also kept a journal, recording in it his ideas about what makes a good artist and the course he was following, which he hoped would make him into the kind of artist he admired. On May 22, 1848, he reported on his wide-ranging studies: "Today I studied *The Voyage of Young Anacharsis*, the *Life of Lord Byron*, the costumes of the Romans, attended drawing classes at the Ecole des Beaux-Arts, and physiology, including the digestive, circulatory, and respiratory systems (how magnificent and delicate they are!), a little of Doctor Gall, and the connections and compression of the arteries and veins." *The Voyage of Young Anacharsis* was a popular late-eighteenth-century novel by Jean-Jacques Barthélémy (1716–1795), inspired by the author's archaeological research. It emphasized ancient science, art, and customs, and as such was considered valuable background material for history painters. The Doctor Gall referred to was the famous German physician Franz Joseph Gall (1758–1828), who promulgated phrenology, a pseudo-science in which specific areas of the skull are said to indicate various personality traits. In addition, dissections of cadavers were often open to the public, and artists of a traditional bent like Bouguereau could attend them to gain a fuller understanding of how the human body worked.

Bouguereau's learning was put to use in telling many different stories. Zenobia's comes from Roman history, that of *Dante and Virgil in Hell*, from the beginnings of Italian vernacular literature, and the tragedy portrayed in *Orestes Pursued by the Furies* (1862; Plate 50), from the ancient Greeks. Aeschylus told the story of Orestes, the son of Clytemnestra and Agamemnon, who killed his mother to avenge the murder of his father. For this he was pursued by the Furies Alecto, Megaera, and Tisiphone, who never let him forget his deed by showing him Clytemnestra's body with his dagger buried in her breast. The critics were not so fond of this painting, writing that it was melodramatic and smacked of school exercises. The canvas remained in the artist's studio for seven years after its exhibition in the Salon of 1863, until it was sold in 1870 to the American art collector and dealer Samuel P. Avery. Despite the critics' disapproval, Bouguereau had high hopes for this grisly picture, as he explained to Avery:

I have this day placed in the hands of your agent my picture of "Orestes pursued by the Furies." Gratified to have the picture go to New York, where I have found so many proofs of sympathy, I do not part with it without some regret; it is a philosophical conception, which I have treated with the utmost care, that of the criminal tormented by remorse; it being dear to me as one of my best and gravest works, on which I rely for admission to the Imperial Academy [the Institut de France], at the doors of which I am now knocking. I will be much obliged to you if you will take all necessary precaution in

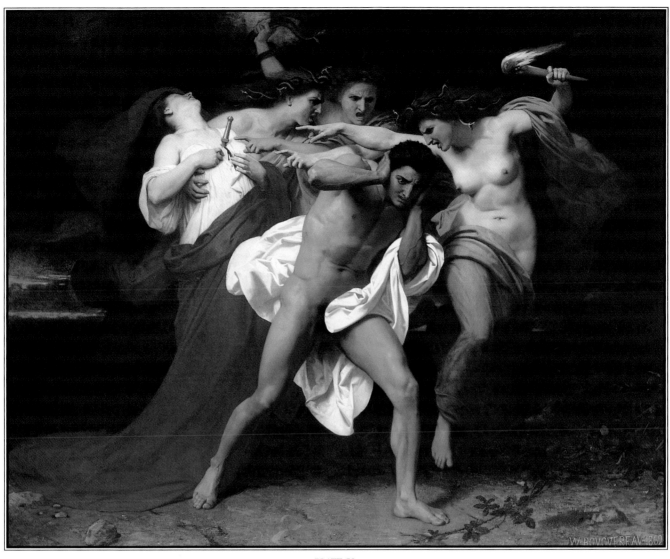

PLATE 50.

Orestes Pursued by the Furies, 1862

Oil on canvas, 231.1 x 278.4 cm (91 x 109⅝ in.). The Chrysler Museum of Art, Norfolk, Virginia, Gift of Walter P. Chrysler, Jr., 71.623.

unpacking and placing it in the frame. If you will also have the kindness to inform me what becomes of it, who purchases it, I shall be grateful, for it is one of my children for which I have always had some weakness.

If Parisian critics found the image unworthy because of its schoolroom atmosphere, Americans welcomed the picture for that very reason. It was presented to the Pennsylvania Academy of the Fine Arts in Philadelphia in 1878 to be an exemplum for students there.

Bouguereau's market sense, as we have seen, developed, and he left behind subject matter that was deemed difficult. He explained late in life: "I soon found out that the horrible, the frenzied, the heroic

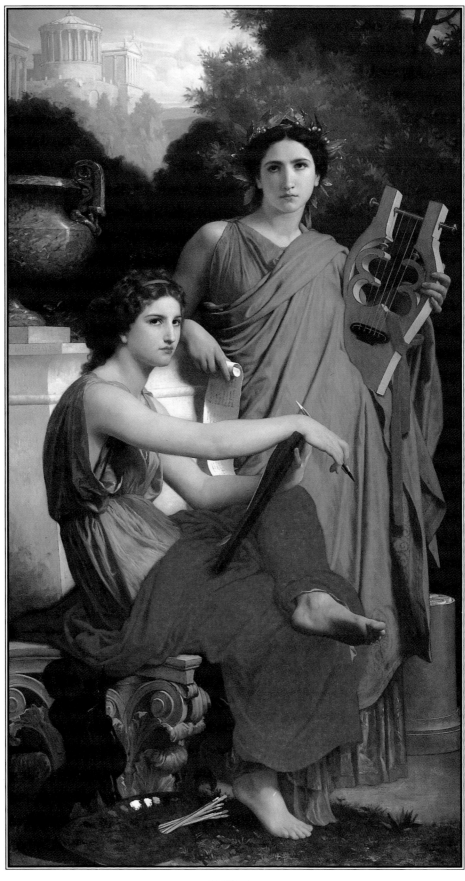

L'art et la littérature (Art and Literature), 1867

Oil on canvas, 200 x 108 cm (78¾ x 42½ in.). Arnot Art Museum, Elmira, New York. Purchase, 1977.

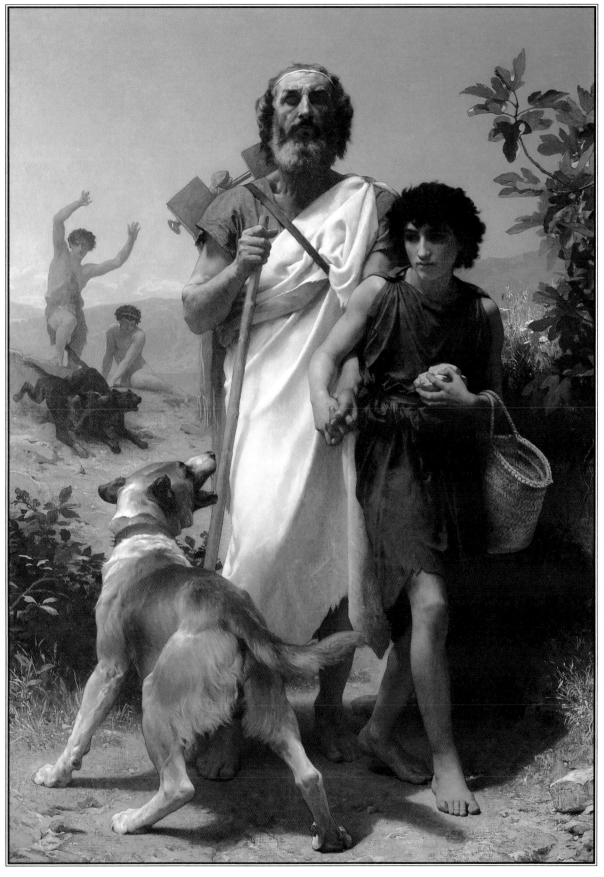

PLATE 52.

Homer and His Guide, 1874

Oil on canvas, 208.9 x 142.9 cm (82¼ x 56¼ in.). Layton Art Collection, Milwaukee Art Museum, Gift of Frederick Layton.

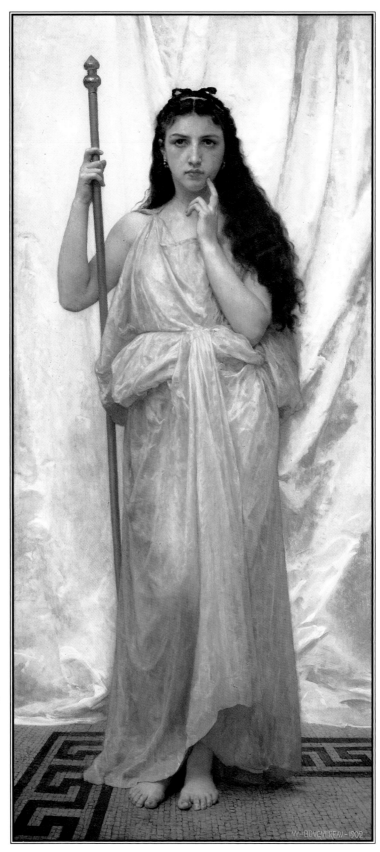

PLATE 53.

Young Priestess, 1902

Oil on canvas, 181 x 81 cm (71¼ x 32 in.). Memorial Art Gallery of the University of Rochester.
Gift of Paul T. White in memory of Josephine Kryl White, 73.1.

does not pay; and as the public of today prefers Venuses and Cupid and I paint to please them, to Venus and her Cupid I chiefly devote myself." When he turned again to classical subjects, they were of a gentler nature, such as *L'art et la littérature* (Art and Literature) (1867; Plate 51), *Homer and His Guide* (1874; Plate 52), and *Young Priestess* (1902; Plate 53).

The allegorical figures of *L'art et la littérature* are some of Bouguereau's most accomplished. They dominate the space, crowded though it is with Corinthian capitals, a palette and brushes, scrolls, porphyry vases, temples both round and rectangular, and the lyre of Orpheus. The colors are both vibrant and cool, and the almost complete lack of patterning allows the full power of the draperies' color to be felt. The bright colors are ones that the nineteenth century knew to have decorated Greek temples and statues, and the crisp drawing is reminiscent of that seen on Greek vases.

Homer and His Guide refers to antiquity once removed, through the neoclassical verses of the late-eighteenth-century poet André Chénier (1762–1794), in which Homer's travels are described. Homer goes to Chios, where he hopes to expose an imposter. Chénier relates how Glaucus, a shepherd boy, ignorant of Homer's identity, takes pity on him and leads him past the barking dogs, which are only doing their job of defending the flock. Homer was a popular subject in the nineteenth century; Homer singing his songs was the subject chosen for the Prix de Rome competition in 1834. Bouguereau departed from the scene usually depicted, however, and instead of showing the poet singing his songs, surrounded by people, presents him as vulnerable, set upon by dogs, with only a boy to guide him. Yet despite the torments of the dogs and the infirmity of blindness, Homer remains a dignified figure, upright and strong.

By the turn of the century, with *Young Priestess*, all reference to narrative is foresworn, and artistic interest is left unfettered to explore forms, lines, and colors, seemingly for their own sake. Pink drapery plays against white, soft flesh, and fluid, diaphanous fabrics contrast with the hardness and geometry of stone mosaic. What cult this woman serves is immaterial, for the artist is truly painting what he sees in front of him. Any classicizing traits are superficial, as they are in the work of the contemporaneous Englishman Albert Moore (1841–1893), who also painted single female figures dressed in flowing draperies. Moore's work is generally considered to have grown from the art of the Pre-Raphaelites and the aesthetic, art-for-art's-sake stance of the American expatriate James McNeill Whistler. Bouguereau may have been responding to these trends when painting *Young Priestess*, and his work gains resonance when seen in this larger context, for it is evident that he delighted in the making of *Young Priestess* as a tour de force of illusionistic painting.

The classical world and the tradition that evolved from it offered Bouguereau endless motifs, most of them, it must be said, of nudes. Bathers, nymphs, Venuses, and allegories abound in his work, as they

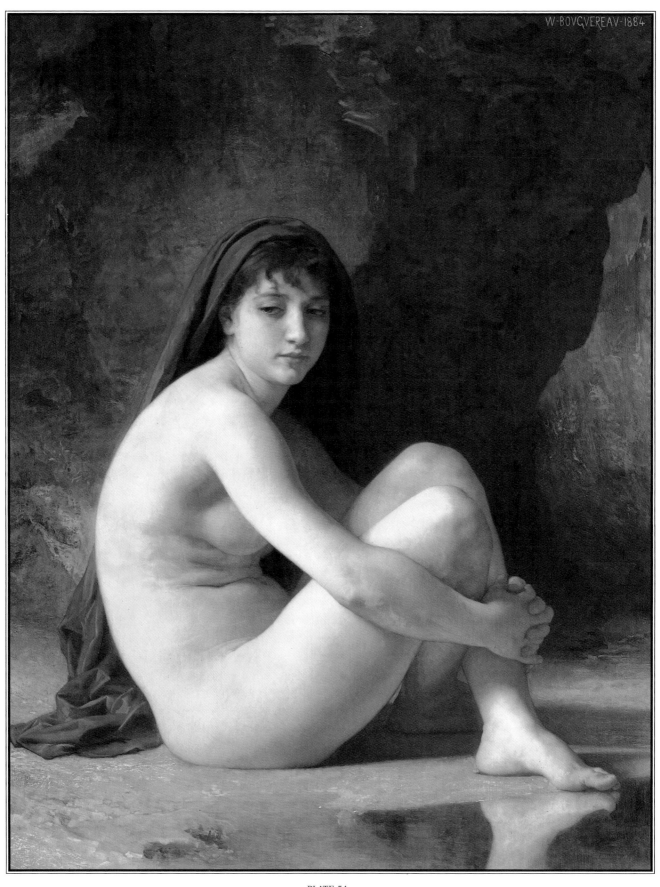

PLATE 54.

Seated Nude, 1884

Oil on canvas, 116.5 x 89.8 cm (45⅞ x 35⅝ in.). © 1996 Sterling and Francine Clark Art Institute, Williamstown, Massachusetts.

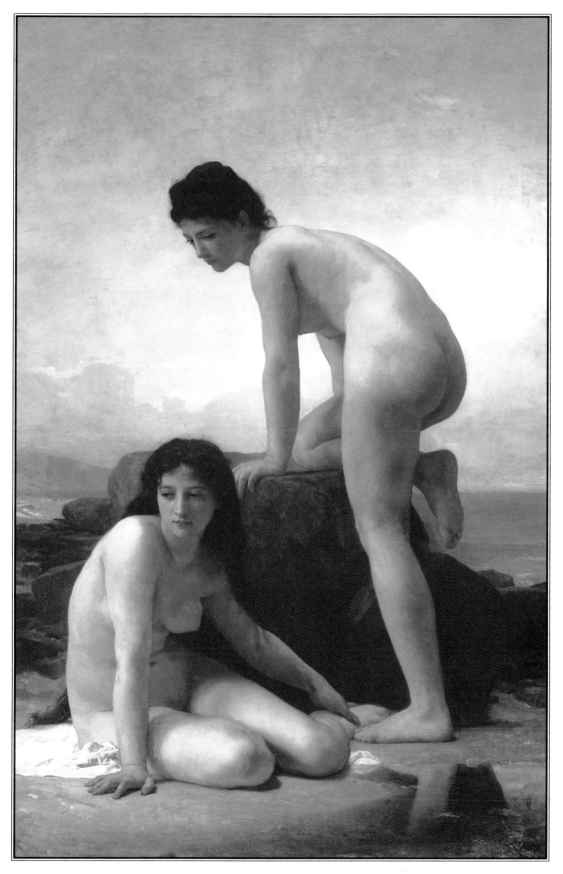

PLATE 55.

The Bathers, 1884

Oil on canvas, 201 x 129 cm (79⅛ x 50¾ in.). A. A. Munger Collection, 1901.458, The Art Institute of Chicago.

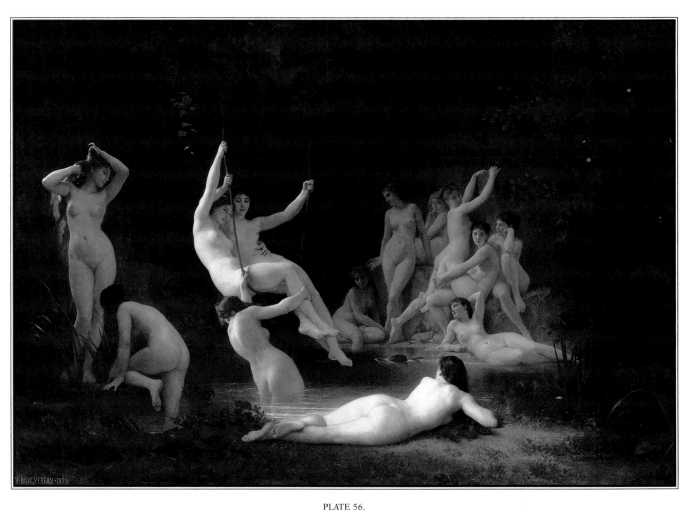

did in the paintings of many successful Salon artists. Bouguereau recognized that the human form was capable of being posed in endless variations. He explained his thinking in a lecture given at the Institut de France in 1885. "Antiquity reveals what an inexhaustible source of variegated inspiration nature is. With a relatively restricted number of elements—a head, a bust, arms, a torso, legs, a stomach—how many masterpieces she has made! Then why seek out other things to paint or sculpture?" Even a small sampling of bathers will bear this out: *Seated Nude* (1884; Plate 54), *The Bathers* (1884; Plate 55), *The Nymphaeum* (1878; Plate 56).

Earlier in the century, Jean-Auguste-Dominique Ingres (1780–1867) had exploited the variety of options possible. His pictures of harems and bathers culminated in *The Golden Age* (1862; Figure 10), in which seemingly every possible position of the human form is catalogued. One of the differences between Ingres's bathers and Bouguereau's is the range of deformations to which Ingres subjected the body—necks are stretched, backs have extra vertebrae inserted, arms and legs appear weight-defyingly boneless. Only in *The*

Nymphaeum does Bouguereau come close to evoking the cloistered, hothouse atmosphere of Ingres's harems. Bouguereau's bathers more often have shed along with their garments any exotic pretext for their nudity. In this matter-of-fact nakedness they come closer to embodying the much-praised ideal of natural nudity that was thought to be the preserve of the ancient Greeks and Romans—and before them of the lucky inhabitants of the Golden Age—than do any of the nudes of Ingres. Even Courbet's nudes retain hints of exoticism and narrative, hints that Bouguereau sometimes courageously does away with. It could be argued that Bouguereau's nudes are chaste. Except, of course, in the case of *The Nymphaeum*. There, the presence of a Greek youth and a satyr at the right invest the image with an overt erotic charge, evoking themes as disparate as the hunter goddess Diana bathing with her nymphs when Actaeon by chance sees them, or the biblical bathers Susanna or Bathsheba, whose privacy is violated by onlookers. Echoes of past art abound in *The Nymphaeum*, but the image also looks forward to such paintings as Henri Matisse's (1869–1954) *Bonheur de vivre* (1905–1906; The Barnes Foundation, Merion, Pa.), in which the beauty of the nude body is celebrated, if with a very different aesthetic. The line Bouguereau draws to define the raised arm and back of the bather foremost in the swing is as abstract as any Matisse would draw.

The figure at the far left, her arms raised to arrange her hair, carries with her a pedigree. The theme of the academic nude in the nineteenth century had been most closely associated with Ingres, and the nude with arms raised was surely meant to recall the type of nude Ingres created in *Venus Anadymomene* (*Anadymomene* is Greek for "rising from the waters") (finished 1848; Musée Condé, Chantilly) or *The Source* (finished 1856; Musée du Louvre). Bouguereau was obviously fascinated with the pose, for he used it not only in *The Nymphaeum*, created especially for the Universal Exposition of 1878, but also, at center stage, in *The Birth of Venus* (1879; Plate 57). It would have been impossible for anyone at all interested in Western art to look at *The Birth of Venus* and not first be reminded of Ingres's figures, and then with their common ancestor, Botticelli's Neoplatonic rendering of the subject from about 1485 (Uffizi, Florence). In remembering the great Renaissance work, the viewer of Bouguereau's vision could not help but be struck by the greater naturalism, solidity of form, and plasticity that Bouguereau achieved in the depiction of the central figure. The goddess of love rises from the sea, unashamed of her nakedness. If as yet unexperienced in the ways of love, this Venus is not afraid of it. Her body, displayed to its full extent—the raised arms are crucial here—is a promise of future gratification, both for herself and for others.

FIGURE 10.

Jean-Auguste-Dominique Ingres (French, 1780–1867)

The Golden Age, 1862

Oil on paper mounted on wood panel, 46.35 x 61.91 cm (18¼ x 24⅜ in.). Fogg Art Museum, Harvard University Art Museums. Bequest of Grenville L. Winthrop, 1943.247.

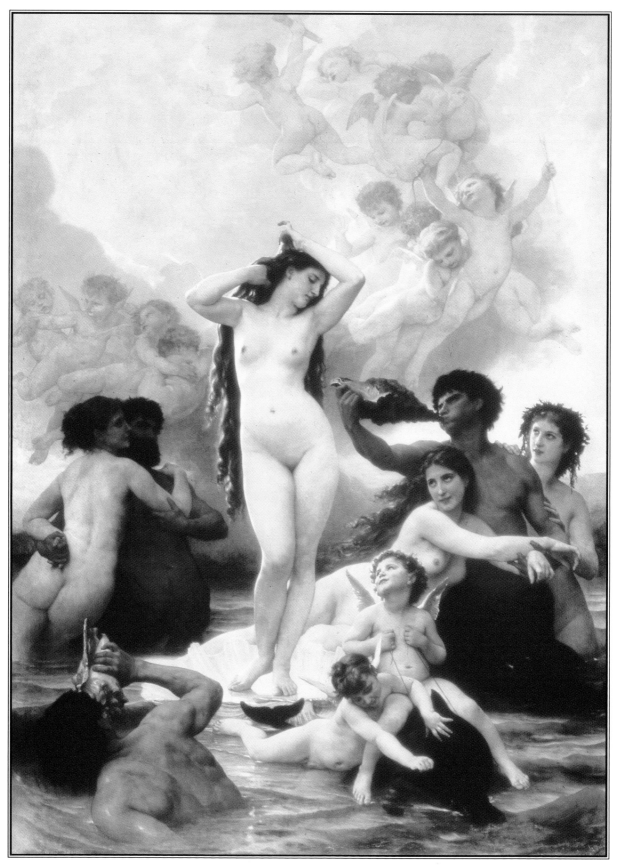

PLATE 57.

The Birth of Venus, 1879

Oil on canvas, 299.7 x 217.8 cm (118 x 85¾ in.). Musée d'Orsay, Paris, RF 253. © Réunion Musées Nationaux.
Photograph courtesy The Bridgeman Art Library, London/SuperStock.

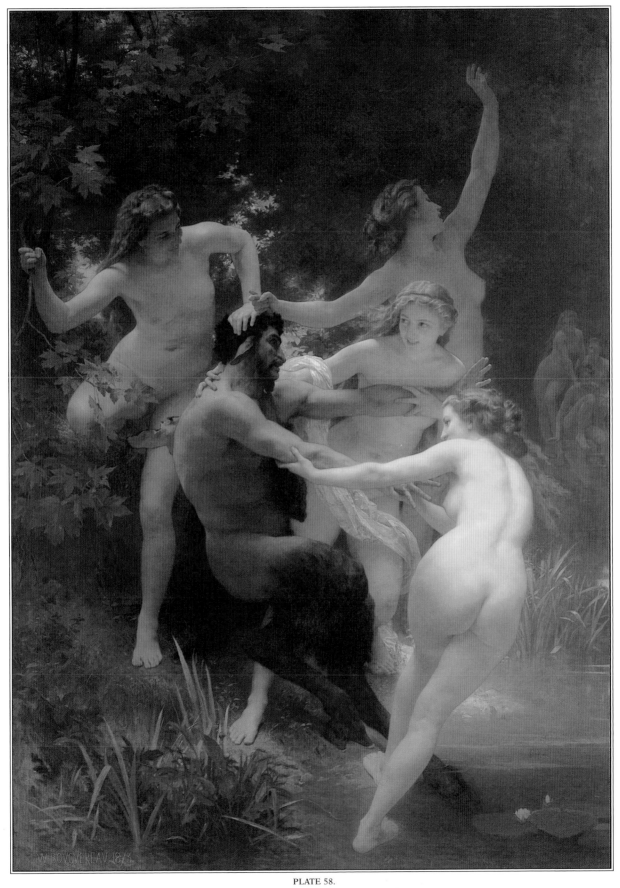

PLATE 58.

Nymphs and Satyr, 1873

Oil on canvas, 260 x 180 cm (102⅜ x 70⅞ in.). © 1996 Sterling and Francine Clark Art Institute, Williamstown, Massachusetts.

Bouguereau could count on his audience's being familiar with the prototype of his Venus, for Ingres's Source was widely known even before its entry into the Louvre in 1878. The Source had been translated into a wide variety of media, from engravings and enamels to porcelains and cameos. In like manner, Bouguereau's Venus can now decorate refrigerator doors in the form of a magnetized doll with a wardrobe of clothes, the feminine equivalent of Michelangelo's David. Is she to be an icon of the 1990s? (For some reason, the figure of the magnetized Venus has been reversed from that in the painting.)

If in *The Nymphaeum* and *The Birth of Venus* the female nudes are presented as singularly passive, those in Nymphs and Satyr (1873; Plate 58) take an active role. We may assume that the satyr was spying on the nymphs while they were bathing, like his counterpart in The Nymphaeum, and that, rather good-naturedly, the nymphs decide to give him a dunking. Something is actually happening here, quite a departure for Bouguereau, whose paintings in general exude a sense of stasis and calm. Nymphs and Satyr entered the collection of John Wolfe in New York in 1873. There it was seen by Earl Shinn, who included it in his compendium of art masterpieces in America. Shinn had no love for Bouguereau, generally complaining of an excess of sentimentality and an absence of originality and sense of life. Nymphs and Satyr, however, engendered this unusually positive response:

The Bouguereau in the Wolfe collection is so unexpectedly fine an exception that one is tempted to drop the lance which habitual prejudice puts into the hand of anybody who is taken to admire a Bouguereau. It is the "Satyr and Nymphs" (5 x 10 feet, [Shinn's measurements are approximate]) painted in 1873. Four or five life-size women of the woods have caught a goat-faced satyr at a disadvantage, and are pulling him into the water by the arms, the ears and the horns. Here are forms of real rounded relief and precipitate action, a wonderful achievement for Bouguereau; here are real windy, balancing trees to form a dark relief for them; the whole combination of life and spirit being so striking that the eye, in high good-humour, is ready to bear witness that the skins of the people are really palpitating and compressible in this case—not Bouguereau parchments scraped down with a razor. The foremost woman is particularly well designed; she really seems to be moving spiritedly away from the spectator, as her polished back leans toiling towards the victim she has seized; her elastic feet grasp the bank along which she climbs, and the light, attracted and cajoled by the long wedge of tempting white flesh, slides gaily down to the eye along the ivory incline of her form, from the head that leans into the background, over the slippery back of her limbs, with their rounded, straining muscles.

One must agree with Shinn: the foremost woman is indeed particularly well designed. She may be the only figure in nineteenth-century art who presents her derriere to the viewer so emphatically.

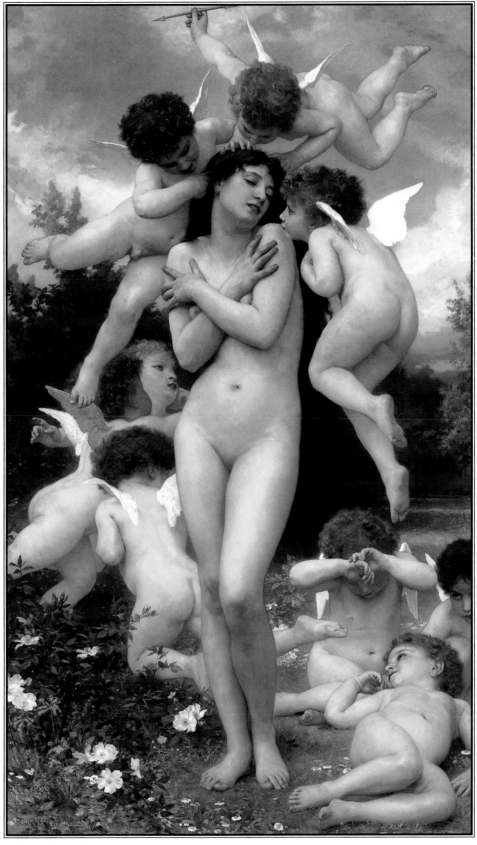

PLATE 59.

Le printemps (The Return of Spring), 1886

Oil on canvas, 213.4 x 127.0 cm (84 x 50 in.). Gift of Francis T. B. Martin. © Joslyn Art Museum, Omaha, Nebraska.

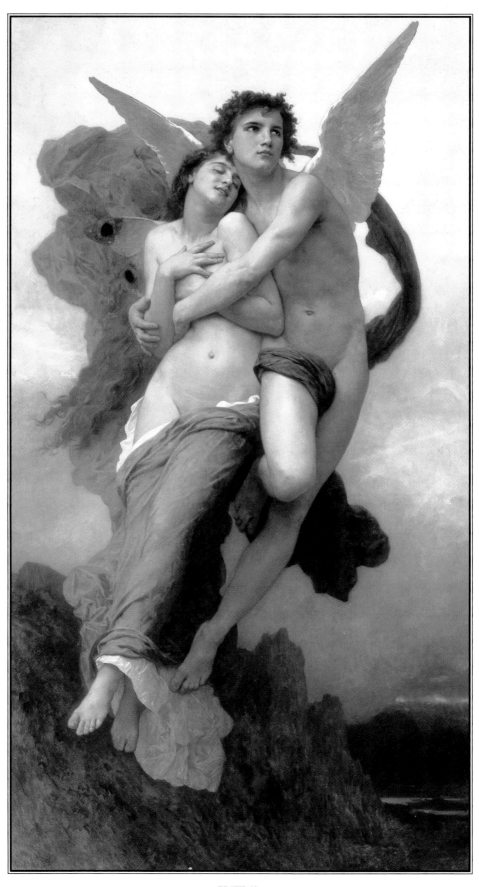

PLATE 60.

Le ravissement de Psyché (The Abduction of Psyche), 1895

Oil on canvas, 209 x 120 cm (82⁹/₃₂ x 47¼ in.). Private collection. Photograph courtesy The Montreal Museum of Fine Arts.

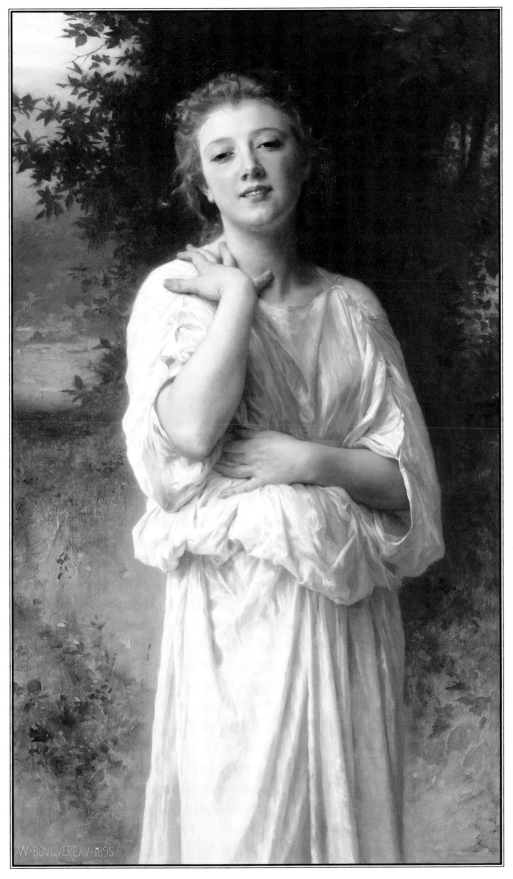

PLATE 61.

Girl, 1895

Oil on canvas, 115.8 x 68.6 cm (45½ x 27 in.). The Carnegie Museum of Art, Pittsburgh. Bequest of Henry Buhl, Jr.

The theme of love, like that of death, runs throughout Bouguereau's career. *Le printemps* (The Return of Spring) (1886; Plate 59) uses an allegorical title to signal the awakening of a young woman's sexual nature, to our late-twentieth-century eyes improbably prompted by Cupids. As soon as it was exhibited in the Salon of 1886 it was accused of embodying "libertine tendencies." Later, a chair was thrown through it when it was shown in Omaha, Nebraska, in December 1890. The perpetrator claimed that he saw red when he looked at it; he wanted to destroy it to protect the virtue of women. When the artist and Elizabeth Gardner learned of the incident, they were dismayed. Gardner wrote in a letter, "Nothing could be farther from Monsieur Bouguereau's heart than to produce an impure figure." Bouguereau was very proud of this painting, writing to his son-in-law, "I'm really thrilled with this last painting; the attitude and expression of the young woman are, I think, exactly right." How far apart at times are the artist's stated intentions and the public's perception.

The appeal of an image like *Le ravissement de Psyché* (1895; Plate 60) is the same as the enduring romance of a young girl's fairy-tale dream of being carried off by a knight on a white horse, or of the impetus that fuels the continuing sales of novels of ravishment, or of the power of the famous scene in the movie *Gone with the Wind* when Rhett Butler carries Scarlett O'Hara up the stairs. If the expression on the face of Spring was deemed by some viewers to be indecent (perhaps because she is shown to be in the company of only her thoughts?), a similar expression on the face of Psyche is comprehensible—she is literally being transported by love. Painted when the artist was seventy years old, *Le ravissement de Psyché* testifies to his continuing abilities not only to create a visually ravishing painting—the color harmonies of purple and blue flooding the canvas are unusual for an erotic subject (reds and pinks are more common) and therefore make the subject more striking—but to gauge the public's taste for such frankly erotic images. A similar sentiment informs *Girl* (1895; Plate 61). Originally entitled *Souvenir*, when seen in conjunction with *Spring* and *Psyche* the nature of the girl's memory becomes obvious.

Less easy for a twentieth-century audience to understand is a painting such as *Admiration* (1897; Plate 62). A series of sketches in oil and pencil leading to this large painting shows that the artist changed his mind several times as to what the subject ought to be. One sketch shows women clustering around a Cupid to clip his wings, thereby depriving him of some of his powers. Another shows a Cupid elevated on a pedestal, worshiped by a crowd of women, a conception close to the Salon work reproduced here. This is love in a more abstracted sense than that seen in *Le ravissement de Psyché* and one that has an art-historical referent in *The Selling of Cupids* (1763; Château de Fontainebleau) by Joseph-Marie Vien (1716–1809), the eighteenth-century teacher of Jacques-Louis David (1748–1825). Vien was a Prix de Rome winner like Bouguereau; his time in Italy, in the 1740s, coincided with the excavations at Pompeii. The images revealed to the public at that time informed Vien's art throughout his career; he

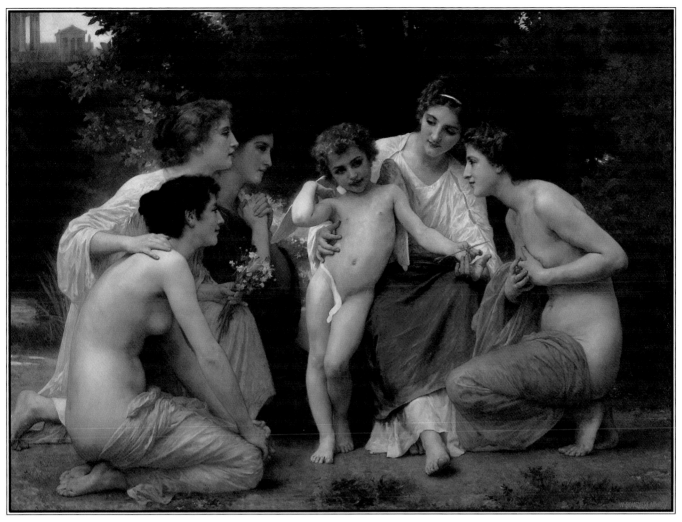

PLATE 62.

Admiration, 1897

Oil on canvas, 147.3 x 198.1 cm (58 x 78 in.). Gift of Mort D. Goldberg, 59.46.10G. San Antonio Museum of Art, San Antonio, Texas.

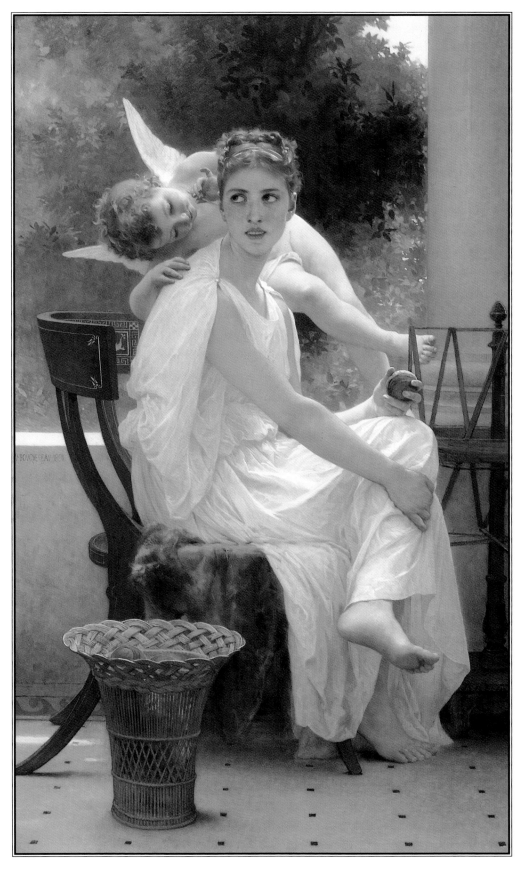

PLATE 63.

Work Interrupted, 1891

Oil on canvas, 163.5 x 100.0 cm (64⅜ x 39⅜ in.). Mead Art Museum, Amherst College. Museum Purchase, 1971.54.

melded antique decorative motifs and bits of narrative into essentially rococo themes, and it is a survival of this interest in pastiche that appears in works by Bouguereau such as *Admiration* or *Work Interrupted* (1891; Plate 63).

The viewer's first impression of *Work Interrupted* is one of texture—of luminous rosy skin, the lightest of fabrics, wispy golden brown hair, lustrous fur, translucent feathers. The light falling on the floor reveals the hardness of the marble, a tactile sensation underscored by the evident pressure of the toes on it. The whole is pale and cool, a rest for the eyes. The naturalism of Bouguereau's technique renders the suspension of the Cupid in midair unsettling, an effect unlike that achieved in the soft-focus manner of Charles Gleyre (1806–1874) in his *Bath* (1868; Figure 11). Critics praised Gleyre's picture in the highest of terms— "It is a picture of a penetrating suavity," "a savoring of the tenderness of flesh and the flowering of life" (Paul Mantz, in *Gazette des Beaux-Arts*, 1875)—while accusing Bouguereau's of rote academicism and a dryness of touch. "Bouguereau is often reproached for the smoothness and polish of his style, for the even

and regular finish which makes perfection a defect" (Shinn again). Pseudo-antique themes were deemed most successful when the technique used to render them was admittedly as artificial as the subjects.

Thus, when Bouguereau eschewed even the slight narrative pretext of *Work Interrupted*, a winding of wool that was not engrossing the young woman much to begin with, and painted single allegorical figures such as in *Evening Mood* (1882; Plate 64), he could concentrate on technique and beauty of line, as did the English painters Albert Moore and Frederick Leighton (1830–1896). The suspended figure became a favorite motif for Bouguereau in the 1880s and 1890s, and it was certainly an apt expression for the tremulous, evanescent time of transition between daylight and darkness.

Bouguereau continued to paint into his last year. If the whereabouts of many of his late works are not known to us today, it must be admitted

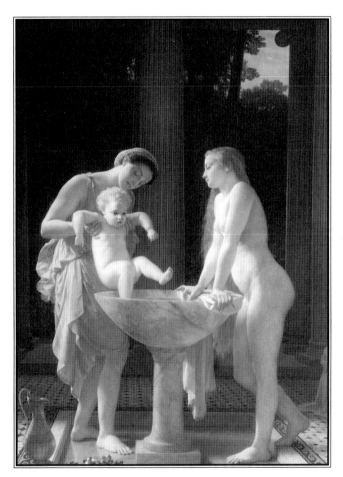

FIGURE 11.

Charles Gleyre (Swiss, 1806–1874)

The Bath, 1868

Oil on canvas, 90.2 x 63.5 cm (35½ x 25 in.). The Chrysler Museum of Art, Norfolk, Virginia, Gift of Walter P. Chrysler, Jr., 71.2069.

that they are often less to our taste than the paintings reproduced here. Titles such as *L'océanide* (The Ocean Nymph) (1905), *Une dryade* (A Dryad) (1904), *La vague* (The Wave) (1903), and *La perle* (The Pearl) (1894) were given to paintings of female nudes either in oddly contorted poses or stretched to full length. With even less narrative or allegorical underpinnings than before, these nudes seem to have been painted solely with the intention of catching the eye.

The art world had changed tremendously in the fifty-odd years that Bouguereau had been a part of it. By 1900 and certainly by 1905, when he died, the tradition in which he had been trained and in which he had successfully practiced his trade had been superseded by any one of a number of revolutionary movements. In 1905 the Fauves shocked the French public with their antinaturalistic colors, Monet and the Impressionists had achieved the status of celebrities, and Paul Cézanne (1839–1906) was at the end of his long series of bathers, which had so little to do with the naturalism of Bouguereau. Bouguereau's nudes must have seemed last gasps, almost desperate attempts to stay in the public eye. His last pictures will not be his legacy, however. Instead, his earlier works, of mothers and children, shepherdesses, and moving depictions of religious faith—portrayed through the lens of tradition and inflected by his masterly draftsmanship and powers of composition—assure his being remembered for those aspects of art he held most dear.

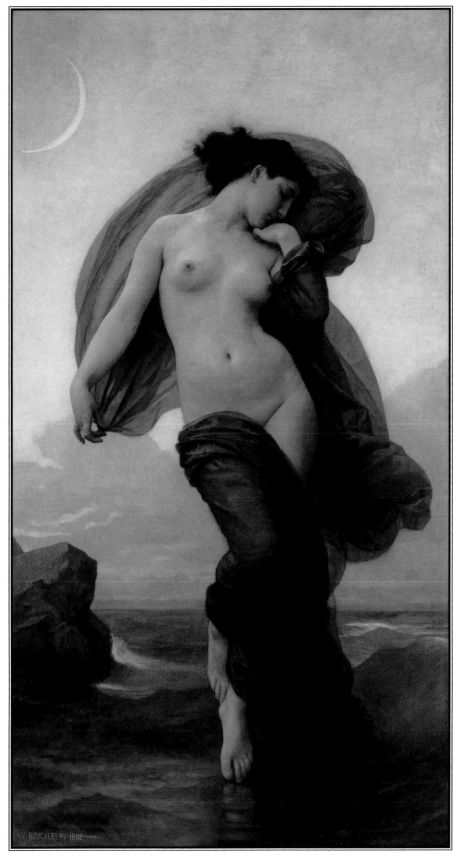

PLATE 64.

Evening Mood, 1882

Oil on canvas, 207.5 x 108.0 cm ($81^{11}/_{16}$ x $42^{1}/_{2}$ in.). National Museum of Art, Havana. Photograph courtesy AKG London.

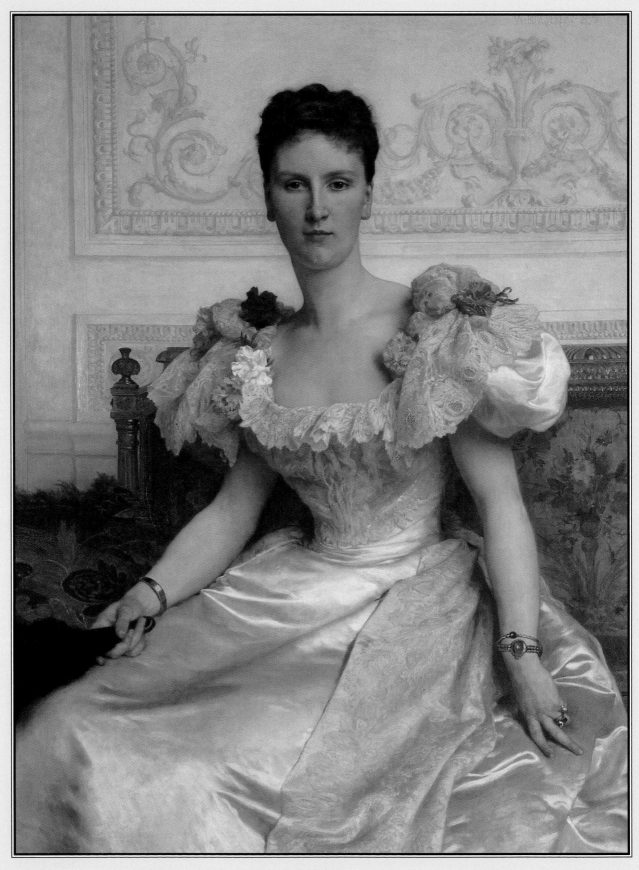

PLATE 65.

Portrait of Madame la Comtesse de Cambacérès, 1895

Oil on canvas, 121 x 90 cm (47⅝ x 35⁷⁄₁₆ in.). The Seattle Art Museum. Purchased with funds from the Eugene Fuller Memorial Collection, by exchange. Photograph by Paul Macapia.

Reception and Reputation

CRITICAL RECEPTION

Written responses to Bouguereau's art underscore the ambivalence with which the critics received his art. Bouguereau was immensely important in the Parisian art world. Consistently elected to serve on the Salon juries by his peers, he was honored both at home and abroad, and his pictures were quickly bought and proudly displayed. In short, he was a force to be reckoned with, but the fact remains that the critics, even conservative critics, found little in his paintings to like. They complained that, despite his indisputable talent and his unsurpassed draftsmanship, he had no genius. His pictures were almost too perfect, in a mechanical sense. The artist's death did not make some critics any more respectful. Frank Fowler, writing in *Scribner's Magazine* in 1905, castigated Bouguereau for not differentiating between Madonnas and nymphs.

Nowhere do we feel that this painter has been stirred by one subject more than by another—he is as competent to present a "Vierge Consolatrice" as he is to depict a make-believe "Bacchante"—both seem to offer opportunities for fine drawing and lovely brush-work, but neither impress you as more than superficially "felt." This is not a complaint that something admirable is not something else, but a regret that it is not admirable, being what it is.

One wonders what Mr. Fowler would have painters do.

Some critics, if they did not approve of middle-class taste, deemed Bouguereau's art inferior. Bannister Merwin, writing in *Munsey's Magazine* in 1907, excoriated Bouguereau's audience:

The popularity of his pictures is still strongest among those who prefer sweetness and pretty senti- ment in art, even if it be cloying to a more discriminating taste. It is still accepted, as a source of regret, that he possessed real talents which, in an unfortunately great degree, he made the servants of a stark commercialism. . . .

The limitations of his temperament were, after all, the limitations of the people he aimed to please.

The artist and writer J. Carroll Beckwith, whose opinions appeared in *Cosmopolitan* in 1890, was more approving of both Bouguereau's art and his audience.

The spirit of the severe classic detail is too cold and abstract for Bouguereau's more amiable artistic nature. *Le juste milieu*, among extremes of temperament and method, is the course of this able mas- ter. Here may lie the secret of his great popularity. The public does not like the jar and shock of tem- peraments like Tintoretto and Courbet. A suave and graceful style, so harmoniously attuned to popular thought that insensibly it elevates to an atmosphere not cold enough to give a chill, yet above the commonplace, improves public taste and gains many warm adherents. The scholarly choice of nearly all of his subjects, and the delicate ideality of their rendering, have appealed to the cultured classes of all lands.

René Ménard summed up a long article in 1875 saying, "whether he paints mythological subjects or rus- tic scenes, M. Bouguereau always exhibits three qualities which justify his reputation: knowledge, taste, and refinement."

COLLECTORS AND DEALERS

No matter what the critics said, these qualities of knowledge, taste, and refinement endeared Bouguereau to the public. His success must have been galling to artists trying to break from the academic tradition. Degas referred to Bouguereau's reputation for a measured, productive life in a letter to his friend Henri Rouart, written December 5, 1872. "You see, my dear friend, I dash home and I commence an ordered life, more so than anyone excepting Bouguereau, whose energy and makeup I do not hope to equal. I am thirsting for order." This is usually interpreted to be high irony on Degas's part; he is, after all, credited with coining the term *Bouguereauté*. It is just as likely, however, that Degas was serious and sincerely envied Bouguereau his productivity, and his success. In addition, Degas revered Ingres and that artist's sinuous line, and he would surely have seen Ingres's legacy continue to live in Bouguereau's art. Likewise, Cézanne is reputed to have referred to the Salon as "Bouguereau's Salon," a preserve denied the artist from Aix.

As we have seen, Bouguereau was honored by the French state with medals and institutional positions. His work decorated churches in Paris and La Rochelle. His *Birth of Venus* has been in French public collections since 1879. His portraits, primarily of members of banking and mercantile circles, mostly remain in private hands (his portraits of the founder of the Parisian department store Au Bon Marché and his wife are still owned by the store). An exception is the ravishing portrait of Madame la Comtesse de Cambacérès (1895; Plate 65). Here Bouguereau's fabled ability to replicate textures is given ample opportunity to show itself in the shimmering satins, rich brocades, and glittering gold and jewels. He deemed that the distractions of the surrounding surfaces were an asset, for they drew attention away from the facial features of the sitter that he found less than appealing. In an interview he named specifically her trumpet-shaped nose and receding chin. Yet the French were not the principal purchasers of Bouguereau's paintings. Americans, newly wealthy in the aftermath of the Civil War, proved to be Bouguereau's most faithful patrons.

Early American collectors of Bouguereau's art were introduced to it through the mediation of the dealer Paul Durand-Ruel. Dealers at the time did more than obtain and sell paintings. They often rented paintings out, a month at a time, for a fee, either to embellish a private residence, for a special party, perhaps, or for the purpose of copying them. People often ordered a bare canvas the same size as the original, mounted on stretchers, at the time they rented the original. Hoping to advance the artist's reputation, and his own of course, a dealer would send paintings in his stock to exhibitions both in the provinces and abroad. In this way Bouguereau's paintings were seen in Bayonne, London, Amsterdam, Biarritz, and Manchester, all arranged for by Durand-Ruel. Photoengravings and chromolithographs of

popular works were made, bringing the price of images within the range of almost anyone with an interest in art. Photographs of paintings were widely circulated, often as Christmas or New Year's greetings. This, of course, is a practice that continues today, as can be seen in the brisk business that museums do in card sales.

The details of the arrangement between Bouguereau and Durand-Ruel are unclear. The dealer first noticed Bouguereau at the Universal Exposition of 1855. Between 1855 and 1867 Bouguereau delivered no more than forty paintings to the dealer, only a small part of his large production. For Durand-Ruel Bouguereau painted primarily Italian or antique themes, paintings with titles such as *Woman from Cervara and Her Child*, *Woman from Tivoli*, or *Woman from Alvito*. After Durand-Ruel introduced Bouguereau to Hugues Merle, in 1862, Bouguereau's art underwent the sea change that resulted in his success. Familial happiness in a contemporary vein overtook antique themes, conforming more closely to Merle's work.

Such pictures already had a healthy market with Americans, among them August Belmont, the representative of the Rothschild banking interests in New York, and Adolph Edward Borie, in Philadelphia, whose money came from an import business. These men had tastes as eclectic as Durand-Ruel's, for not only did they buy academic paintings by Bouguereau, Horace Vernet (1789–1863), Paul Delaroche (1797–1856), and Ernest Meissonier (1815–1891), but they hung them next to works by painters who now have reputations as being more progressive, such as the landscapists identified with Barbizon—Théodore Rousseau, Jean-Baptiste Camille Corot, Charles Jacque (1813–1894), and Jules Dupré. Their collections, primarily of contemporary French painting, gave a much more balanced view of current, if conflicting, trends in French art than can often be had from installations in museums today.

Middlemen were also involved in some of these transactions. George A. Lucas acted as agent for the collectors John Taylor Johnston, William T. Walters, and Alexander T. Stewart. Samuel P. Avery, who was both a collector and a dealer and who used Lucas's services, opened a gallery in New York and bought from Durand-Ruel, as did William Schaus. There began to be many avenues through which Bouguereaus could be bought. But perhaps because Durand-Ruel did not demand that Bouguereau turn over all his paintings to him, or perhaps because while associated with Durand-Ruel Bouguereau had not yet hit his stride, the arrangement between the two was not particularly lucrative for either one. So when, at the end of 1865, Goupil offered Bouguereau an exclusive contract, Bouguereau placed his affairs in Goupil's hands. Goupil bought what paintings by Bouguereau Durand-Ruel had in stock and received all of Bouguereau's current production.

Between the years 1866 and 1887 Bouguereau delivered to Goupil ten or twelve paintings a year. A vast majority of these were sold to American, British, Dutch, or Belgian dealers, and most of them to

Michael Knoedler in New York and Wallis in London, who ran the French Gallery there. For each painting Bouguereau gave to Goupil, he received a fixed sum plus half of the profit the dealer made. Goupil and these dealers handled many of the paintings reproduced in this book. *The Thank Offering* (see Plate 22) was sold by Goupil to Wallis in 1867 and *Little Marauders* (see Plate 34) to Theo Van Gogh (Vincent's brother) in Amsterdam in 1872. To Knoedler in New York Goupil sold *The Shell* (see Plate 66) in 1872 and *Charity* (see Plate 42) in 1878. To Schaus went *Temptation* (see Plate 25) in 1880. Everyone made money in these transactions. Bouguereau received 6,000 francs from Goupil for *The Shell* and another 5,500 when the dealer sold it to Knoedler for 17,000 francs. *Charity* brought the artist 33,500 francs: 22,000 when he delivered it to Goupil, and, when Goupil sold it the same day to Knoedler for 45,000, an additional 11,500 francs.

Both before and after his arrangement with Goupil, Bouguereau handled his sales directly. He sold *Admiration* (see Plate 62) to Arthur Tooth & Sons in London and *Orestes Pursued by the Furies* (see Plate 50) to George Lucas for Samuel P. Avery in 1870. Thomas Wigglesworth of Boston brought *Fraternal Love* (see Plate 17) to this country sometime before 1869. This was the first work by Bouguereau to appear in Durand-Ruel's account books, perhaps bought from the dealer Ernest Gambart in London, which indicates that it was another painting the artist had sold himself. Avery bought it from Durand-Ruel, and from there it made its way to Wigglesworth. *Nymphs and Satyr* (see Plate 58) entered the collection of John Wolfe in New York, apparently directly, and *Pietà* (see Plate 47) seems to have been sold to the prince Demidoff in 1876 without being entered in Goupil's account books.

L'art et la littérature (see Plate 51) was commissioned by J. Stricker Jenkins, a Baltimore collector, very early, in 1866. Lucas was the intermediary, working in Paris as the agent for Avery. Earl Shinn reported that Bouguereau "expressed unusual delight to his American patron for a chance to give a loose to his classical feeling and idealism in a kind of theme which the dealers, enamored of his accomplished peasant-girls, seldom allowed him to attempt." If this sentiment is accurate, it recalls Thomas Gainsborough's (1727–1788) or John Singer Sargent's (1856–1925) dissatisfaction with the necessity of painting portraits, when they would rather have been painting landscapes. Even astute businessmen, like Bouguereau, sometimes want to follow their hearts instead of the market, and the classicism of *L'art et la littérature* seems to have meant more to Bouguereau than did his wildly successful shepherdesses.

Alexander Turney Stewart, a dry-goods merchant who after the Civil War became one of the wealthiest men in the United States, was a loyal patron of Bouguereau. Having bought *The Shepherdess* (see Plate 27) and *Homer and His Guide* (see Plate 52), the latter from the Salon of 1874, that same year Stewart commissioned Bouguereau to paint "the artist's greatest work, and not a nude subject." The result was *Return from the Harvest* (see Plate 35). The artist obviously interpreted the injunction against nudity to apply to adult figures, and not to children. These two paintings were among the many displayed in

Stewart's picture gallery, where they were hung in typical nineteenth-century fashion, that is, packed frame to frame and floor to ceiling. Paintings on the walls vied for attention with sculptures, most full size in white marble, in the middle of the long room.

Bouguereau's paintings of mothers and children struck a deep, resonant chord with Americans. Many factors contributed to the popularity of images showing loving mothers, attentive fathers, and healthy, happy children. This ideal became increasingly important as the nineteenth century progressed. As in Europe, society's roots in rural patterns were disrupted by industrialization and urbanization, and the Civil War threw into relief changes that had not been as evident earlier. A feeling of despair and moral unease was pervasive enough to cause Lewis Mumford, the social philosopher whose works explore the relationship between humans and their environment, both natural and constructed, to label the thirty years after 1865 "the Brown Decades." Bouguereau's paintings, with their pedigree of centuries-old academic training easily visible, could to some extent counteract feelings of uprootedness. American artists such as Eastman Johnson (1824–1906) and Lilly Martin Spencer (1822–1902) provided views of happy,

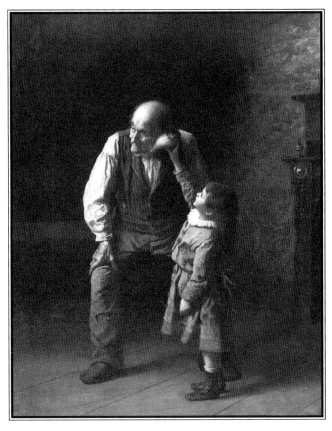

contemporary families, yet a comparison of Johnson's *What the Shell Says* (1875; Figure 12) to Bouguereau's *Shell* (1871; Plate 66) shows how different American and European approaches to the same theme could be. Johnson paints in browns and grays touched with bits of white and red, his surfaces are only as descriptive as they have to be, and he is concerned more with atmosphere than detail. By contrast, the craft of Bouguereau's art is always apparent, and the emotional effect is very different. The figures are posed in such a way as to emphasize the flawless drawing that underpins their complicated forms, and the clothes of lace, silk, and rich brocade have been lavished with attention. The positions of Bouguereau's mother and child—both facing forward, the mother behind the child—deny true interaction, as if the upper-middle-class station they enjoy prevents the easy, everyday intimacy of Johnson's grandfather and granddaughter, couched in cozy, warm browns. These differences depend on many factors, among them class,

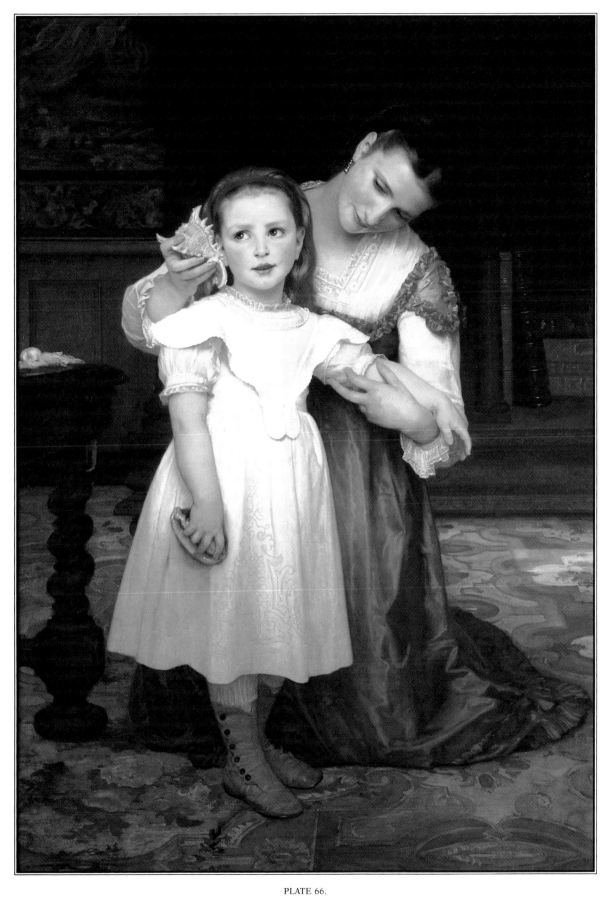

PLATE 66.

The Shell, 1871

Oil on canvas, 130.8 x 89.5 cm (51½ x 35¼ in.). © 1996 Sotheby's, Inc.

culture, nationality, and artistic intent, and not on the quality of the artist. Only a truly eclectic collector could appreciate the merits of both painters.

Many an American collector would buy a Bouguereau rather than a Johnson for the simple reason that Bouguereau was French. There was (and some would argue still is) a bias in this country against American art and artists, a distrust seemingly founded on a sense that art is not useful or pragmatic, not businesslike, not American. When newly rich Americans wanted to buy art—because it is what wealthy people did—very few elected to buy works by their countrymen. When Shinn catalogued the art collections in America in the 1870s, he found that most of them contained primarily European works. The levying of tariffs on European paintings was an attempt to support American artists, but the tax seems not to have had an appreciable effect, given the numbers of contemporary European paintings that were regularly imported in the second half of the nineteenth century. Clarence Cook, writing in his book *Art and Artists of Our Time*, published in 1888, summed up the reigning American attitude regarding Bouguereau, even if he did not share the enthusiasm he recorded.

Hardly any French painter can be named who is more widely popular in America than Bouguereau. His pictures always meet with a ready sale at large prices, and at the exhibitions they are sure of approval from the majority of the visitors, who would probably pass by Delacroix, Decamps, or Puvis de Chavannes, with small notice, or none at all. The reason of this is not far to seek. Mr. René Ménard says of Bouguereau that he always exhibits three qualities which justify his reputation: knowledge, taste, refinement. This is certainly true, and to parody Mr. Lincoln's delightfully ingenious non-committal verdict upon a lecture that was read to him for his opinion: "For those people who like that sort of lecture, I should think that would be the sort of lecture those people would like," we might say, that for those people who look for nothing more in a picture than knowledge, taste and refinement, Bouguereau's pictures are the sort of picture those people would like. He is, to begin with, a perfect draughtsman of the human body, and is not averse to proving his knowledge by putting his models in a great variety of attitudes, never avoiding the most difficult fore-shortenings, as if he enjoyed over-coming difficulties. He draws hands and feet irreproachably; in fact, he is recognized as a master in this field. Then, again his taste keeps him always far removed from the eccentricities that are so much in vogue with many of the younger artists of our day, and so much enjoyed by a considerable number of people. Bouguereau never forgets that he is painting pictures that are to be bought by rich people for the adornment of their drawing-rooms, and he takes care that nothing in them shall be out of keeping with the tasteful and elegant things that surround them. Since one of the things that rich and fashionable people take pleasure in, is the knowledge that there are others in the world who are not as well off as themselves, Bouguereau has provided for his admirers an ample supply of pretty beggar-children, young peasants, mothers of the picturesque poor, and so forth and so on, who are in truth people of the upper class, or seem to be such, with beautiful faces, fine heads of hair, rich eyes, chis-

elled lips, ivory skins, hands that never wore gloves, feet that never wore shoes, and all in a state of immaculate cleanliness, and in garments where, if a patch or two is to be seen, it is accepted as mere symbolism, and offends nobody. An irreproachable refinement of sentiment goes hand in hand with this irreproachable taste. The French "freedom" which offends so many people here and in England, and many people, be it said, in France as well, is never betrayed in Bouguereau's pictures; they are as pure, as passionless and as cold as an anchorite could desire. Now in an orderly society regulated by wholesome rules dictated by conventional propriety, such a painter is sure of his reward; and as such a society is naturally founded on sound commercial principles, it is an added recommendation that whoever gets a picture by Bouguereau gets the full worth of his money, in finished painting, first-rate drawing, and a subject and treatment no well-bred person can find fault with.

TEACHING

An artist can make his mark in many ways. The most desired avenue is through the works themselves, and we have seen that replicas, prints, and photographs of famous works help spread an artist's reputation. In the nineteenth century another measure of success was an artist's students, who would carry on the teacher's precepts in one way or another in their own works. Many American artists went to Paris to study, in the hopes of attaining a technical proficiency they felt was unavailable in the United States and to immerse themselves in the art treasures that had over the centuries accumulated there. When American artists went to Paris, they followed the same course of study as Bouguereau had.

Foreigners and Frenchmen alike could take the admissions tests to the government-sponsored Ecole des Beaux-Arts. The first step was passing tests in anatomy and perspective, and in ornamental design or world history. Answers to these tests had to be given in French, of course, which was a hindrance to some of the hopefuls. If an applicant made it past the first step, the next was the more critical—execution of a drawing after a cast of an antique sculpture or from a live model, to be completed in two six-hour sessions in a private cubicle. The importance of this test lay not only in the fact that success in it admitted the student to the Ecole but also in that a student's merit relative to the others' determined his position in the studio vis-à-vis the model. A passing performance, but one near the bottom of the group, meant that the student was placed far from the model when it came time for actual classes in drawing, for, it will be remembered, only drawing was taught at the Ecole. Private studios, or ateliers, were the forum for instruction in the practical aspects of painting, and many Americans studied in the ateliers run by Jean-Léon Gérôme, Alexandre Cabanel, Léon Bonnat (1833–1922), and Carolus-Duran.

It is surprising that Bouguereau did not establish such an atelier. The duties incumbent on the teacher seem not to have been onerous, involving a visit once a week or so to critique the students' work.

Bouguereau eventually taught a nighttime drawing class at the Ecole, starting in 1888, but as early as 1875 he taught at the Académie Julian, an alternative school founded by Rodolphe Julian (1839–1907) in 1868. Unlike at the Ecole, there were no entrance exams, and the fees were nominal compared to those levied at other ateliers. Furthermore, the Julian admitted women, and Elizabeth Gardner studied there beginning in 1873. Women's fees were at least twice as high as those for men, and women were eventually placed in a separate studio, yet the opportunities there were greater than at any other school in the city. By the mid-1880s the Académie Julian, with about four hundred students, was the largest art school in Paris. (After 1883 the Ecole des Beaux-Arts

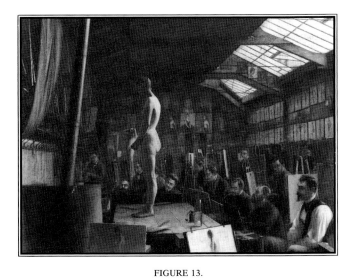

FIGURE 13.

Jefferson David Chalfant (American, 1856–1931)
Bouguereau's Atelier at the Académie Julian, Paris, 1891

Oil on wood panel, 28.3 x 37.1 cm (11⅛ x 14⅝ in.). Fine Arts Museums of San Francisco.
Gift of Mr. and Mrs. John D. Rockefeller 3rd, 1979.7.26.

admitted eighty students per year, up from seventy.) And unlike at the Ecole, at the Julian students would draw or paint from the live model (see Figure 13), some hoping to improve their abilities so that they would be accepted at other studios or even at the Ecole itself. The teachers at the Julian taught in pairs, each giving critiques in alternate months, so as to discourage a student's following any one style too closely. Julian seems to have been a paragon of tolerance and open-mindedness, offering opportunity for academic instruction rather than prescriptive rules, an especially attractive option for Americans.

Some of Bouguereau's American students are well known to us today—Cecilia Beaux (1855–1942), Robert Henri (1865–1929), Thomas Anshutz (1851–1912), and Louis Eilshemius (1864–1941). The reputations of many more such as Albert Sterner (1863–1946) and Louis Paul Dessar (1867–1952) are not as prominent. Americans who studied at the Julian under teachers other than Bouguereau include William Paxton (1869–1941), Henry Ossawa Tanner (1859–1936), the future photographer Edward Steichen (1879–1973), Maurice Prendergast (1858–1924), Thomas Wilmer Dewing (1851–1938), and Kenyon Cox (1856–1919). This short roster hints at the stylistic diversity allowed and even encouraged at the Julian. In addition, it shows that as late as the 1890s, when Impressionism was already twenty years old, academic training was still a viable choice for many aspiring artists.

Students were appreciative of what Bouguereau could teach them, and those who desired unvarnished criticism gravitated to him. We are fortunate in that some of these students kept detailed journals that tell us much about Bouguereau's personality and approach to teaching. Of course, Bouguereau's phenomenal success in the marketplace did not go unnoticed. As William Fair Kline

(1870–1931) remembered, "Bouguereau's criticism to everybody [was], 'It is good but it is not good enough.' He would not discourage you, but a thing could always be better. He was a nice old fellow. He was one man who made a fortune. He made two million dollars out of his paintings. . . . He had a reputation of having made more than any other artist." The Académie Julian published a monthly magazine between about 1901 and 1917. The March 1912 issue reported on Bouguereau's teaching method: "He would stop before each easel, would critique the drawing, modify the palette, and would never leave without giving a word of encouragement—'My good friend, we'll look at this again on Saturday.'" Interestingly, one student reported that "Bouguereau admires in others the very opposite qualities which distinguish his own work. 'Faire large et simple' [Make it large and simple] is his advice, and anything like imitation of his own style finds little sympathy with him." Edmund Wuerpel (1866–1958) wrote in his journal:

As long as he was in the room, there was absolute silence. Only the reply to a question addressed to the student who was receiving a criticism, broke the monotony of that gentle soothing voice. It usually took three hours to criticize the entire class during which time the models shifted their positions only as the master moved from one student to another, resuming the pose exactly and quickly as a new criticism began. Endlessly from one easel to another the little man shifted or glided and spoke words of criticism or praise. Always gentle, always fair, never saying things he did not really mean, it was a pleasure as well as a privilege to listen to him.

From these reminiscences it is clear that Bouguereau approached his duties seriously, sincerely trying to help the students, because art and beauty, as embodied in the human figure, were so very important to him. One comment here. The phrase "the little man" in the last quotation is simply descriptive: Bouguereau was no more than five feet three inches tall.

METHOD

What, exactly, did students learn at the Académie Julian? Several books, much longer than this one, have been written on the subject of the art academies in Paris, and their titles may be found in the Suggested Reading list. Bouguereau and the other teachers would have taught the students the techniques they themselves used.

Bouguereau typically went through many different steps to prepare for a painting. First was the quick thumbnail sketch, almost a scribble, establishing the main outlines of the composition. He made highly finished drawings for all the figures in the composition, as well as studies of draperies, accessories, and even foliage. Oil studies of heads, hands, and any animals followed. Then he was prepared to make the

cartoon, or full-size drawing, to make sure the composition as envisioned would coalesce properly at full scale. Only after all these steps were taken did he feel ready to begin the oil painting itself.

Crucial to this procedure, of course, was drawing. *A Nude Study for Venus* (1865; Figure 14) is a typical preparatory study, in this instance of the goddess Venus in the grand decorative cycle of Apollo and the Muses, which Bouguereau painted for the ceiling of the Concert Hall of the Grand Théâtre of Bordeaux. Bouguereau used pencil and sparingly highlighted selected areas with white chalk to show where the brightest light models and defines forms, particularly where forms change planes, as at the perceived edges. One believes fully in this three-dimensional figure, because it shows how completely Bouguereau understood the human body. Yet it also shows that drawing as taught at the Ecole des Beaux-Arts and, by extension, at the Académie Julian was more than simple outlines, for within the line that sets the figure apart from the background are almost unimaginably subtle modulations of pencil work that describe the ever-changing swellings and hollows of the human form.

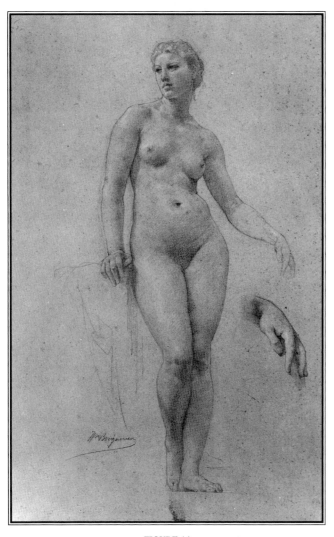

Studio models were required to maintain a pose for long periods of time. To help them do this, supports of various kinds were provided, somewhat after the example of classical sculptures in marble, wherein supports in the form of tree trunks or draperies connected body parts to the base of the sculpture. We can see in *A Nude Study for Venus* that the right hand rests on such a support. Hands are very difficult to draw, and Bouguereau wanted to get the left hand correct, so he did it twice. It, too, rested on a support, which one can extrapolate from the more finished, disembodied hand.

Sketches in oils were very different things from the finished picture. Bouguereau's sketch for a Charity figure, with two babies nestled in her arms (n.d., Figure 15), and the sketch for *Song of the Angels* (c. 1881, Plate 67) set out, in color, the full composition, with special care given to the tonal relationships. Some twentieth-century viewers may appreciate the lack of finish, the traces of the brush as evidence of the artist's hand and personal-

ity. Bouguereau, however, considered such a sketch not to be a painting at all, in the sense that he understood the word. It was simply a step on the way to the final work of art, the highly finished public painting. Such private work was not meant to be seen outside the studio. It is exactly on this point—of finish versus non-finish, of drawing versus painting—that artists such as Monet and Renoir broke from the academic process, although they, too, had begun their careers as students in the atelier of the academic painter Charles Gleyre. Monet and his colleagues decried the academic method as antithetical to modern life, to the way they perceived the world. They were eager to exhibit paintings that re-created optical experience with brash, visible brushstrokes, paintings that did not adhere to a preordained style.

For his part, Bouguereau was mystified by the work of artists who chose paths independent of the Ecole. He explained his position in his address to the Institut de France. On the importance of study and practice, he had this to say:

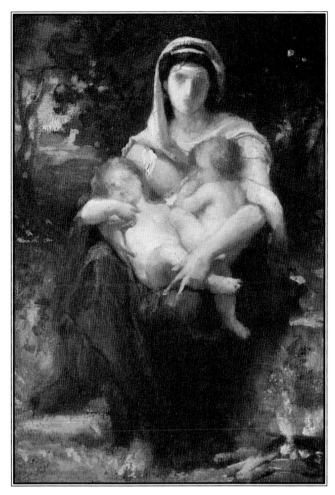

FIGURE 15.

Sketch for *Charity*, n.d.

Oil on wood, 28.6 x 20.6 cm (11¼ x 8⅛ in.). The George A. Lucas Collection of The Maryland Institute, College of Art, on extended loan to The Baltimore Museum of Art, L.1934.48.40.

One can always acquire the accessory knowledge that goes along with the production of a work of art, but never—and I insist upon this point—can will, perseverance, or obstinacy in one's mature years make up for lack of practice. And can greater misery be conceived than that experienced by the artist who feels the fulfillment of his dream compromised by the impotence of his execution? . . .

I am very eclectic, as you see. I accept and respect all schools of painting which have as the basis of their doctrine the sincere study of nature and the search for the true and the beautiful. As for the impressionists, the pointillists, etc., I cannot discuss them. I do not see the way they see, or claim to see. That is the only reason for my negative opinion about them.

Thus, both Bouguereau and the artists known as the Impressionists claimed to base their work on the same foundation, reality. It was, as Bouguereau said, a matter of seeing differently and, one might add, of a different definition of reality.

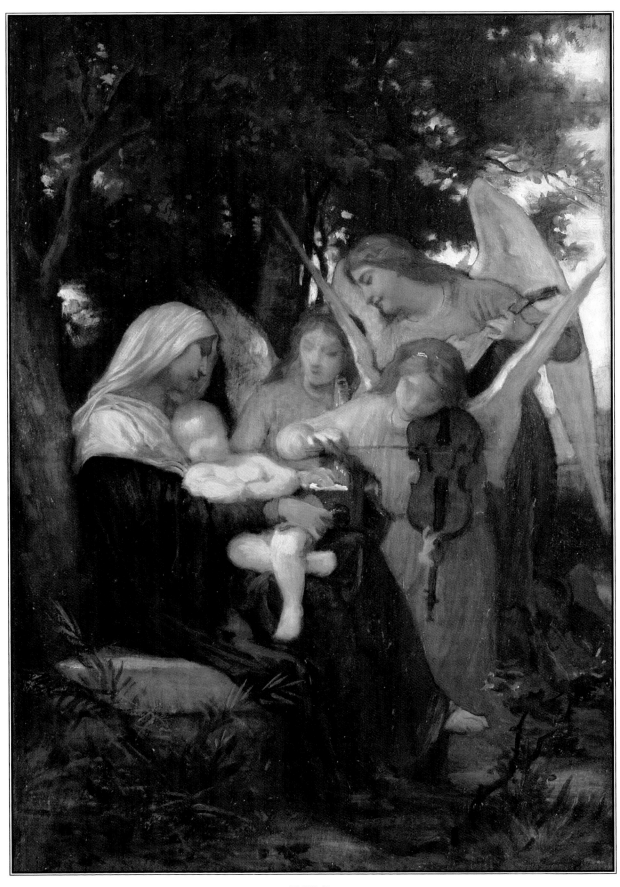

PLATE 67.

Sketch for Song of the Angels

Oil on canvas, 39.4 x 27.9 cm (15½ x 11 in.). © 1996 Sotheby's, Inc.

ELIZABETH JANE GARDNER

Bouguereau's second wife, Elizabeth Jane Gardner, makes a fascinating study on her own account. She was unusually successful in her quest to make a name for herself in the French art world, but her struggle was long. She spent her entire adult life in Paris. This, in addition to her fluent French, set her apart from the majority of American students. Our knowledge of her comes primarily from the letters she wrote to her family, in which she is refreshingly frank about the art world in which she was trying to make her way. Born in 1837, Gardner, with Imogene Robinson—her former art teacher from the Lasell Female Seminary in Auburndale, Massachusetts—arrived in Paris in 1864 to study art. Already somewhat accomplished, they made copies of works in the Louvre and Luxembourg Museum for patrons in the United States. Having copies made of acknowledged masterpieces was an acceptable form of art patronage in the nineteenth century, and many young artists supported themselves by supplying them. But by mid-November, when it became too cold to stay in the unheated galleries, the women sought formal training. Gardner studied with Jean-Baptiste Ange Tissier (1814–1876), whose students were mostly young women, although he did arrange to have a live model come to pose for them four times a week. In addition, by early 1865 Gardner was part of a women's cooperative studio and was able to attend classes at the Gobelins Tapestry Manufactory school by wearing boy's clothes.

She had exceptional good luck with the Salon jury. In 1868, only four years after arriving in Paris, she could write to her family: "but when the ex'n opened *both of mine* were hung in full view among foreign artists and raises the value of what I paint." To give themselves a pedigree, young artists often named their teachers in the Salon catalogues. Between the years 1868 and 1874, Gardner listed Hugues Merle, in 1875 she added Jules-Joseph Lefebvre (1834–1911), and in 1877 she gave Bouguereau's name in addition to the other two, a validation she kept until at least 1894. Although she must have had some family money, Gardner needed to sell her works in order to live. In addition to painting, she acted as art agent for Americans. The dealer Goupil began buying her pictures in the late 1870s, and by the mid-1880s her paintings sold for as much as $1,600. By 1884 her reputation was good enough for Knoedler's gallery in New York to buy her Salon picture sight unseen, confident of its quality.

Yet for Gardner, as for all other artists who wanted success at the Salon, the goal was a medal. This she attained in 1887.

My pictures at this year's Salon have just received the medal which I have waited for so many years. . . . The jury voted me the honor by a very flattering majority—30 voices out of 40—

and it is the only medal given to an American since the new tariff [a tariff of 33 percent levied against European works of art imported into the United States]. No American woman has ever received a medal here before. . . . Monsieur Bouguereau is very happy at my success. He is as usual President of the Jury. It is his great impartiality which has so long kept him in office. He has always said that I must succeed through my own merit and not by his influence.

While we may wonder at her disingenuousness, the medal was nonetheless hers, and it was indeed a signal honor. She had accomplished what she had set out to do, against the considerable odds of her nationality and gender. And she was willing to postpone personal happiness in favor of her career. After Bouguereau's death, Elizabeth told a reporter that Mme Bouguereau had let it be known that she thought that one artist in the family was enough. Elizabeth commented, "and so do I—now. It was because of my passion for painting that I refused to marry when I was younger, and had yet to win position as an artist. When I was older I saw the wisdom of his mother's objection; and when he was alone and needed me I abandoned the brush. Voila tout!" Not quite everything, however, for after Bouguereau's death, in 1905, Gardner again picked up her brush and continued her career as a painter. Although some today might criticize her for relegating her career to second place in favor of her husband's, she was content to do so.

Writers on Bouguereau and Gardner often say that her style closely followed his, and indeed, some of her paintings may still be attributed to him. She herself said in an interview in 1910, "I know I am censured for not more boldly asserting my individuality, but I would rather be known as the best imitator of Bouguereau than be nobody!" Certainly a painting such as *By the Seashore* (n.d.; Figure 16) shares much with Bouguereau's art, in general conception, pose, finish, and even in the style of the signature. The presence of "Bouguereau" in this signature dates the painting to after 1896, when they were married, and probably to after 1905, since she seems not to have painted while they lived together as husband and wife. A work like *Dans le bois* (In the Woods) (1889; Figure 17), shows her more

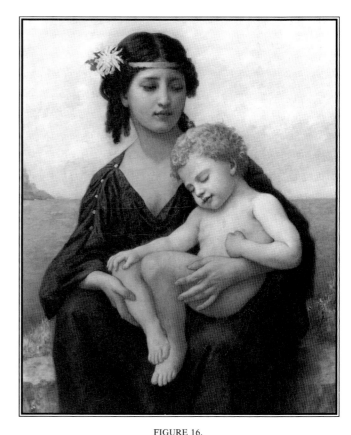

FIGURE 16.

Elizabeth Gardner Bouguereau (American, 1837–1922)

By the Seashore

Oil on canvas, 78.8 x 98.4 cm (31 x 38¾ in.). Gift of Mrs. C. N. Dietz. © Joslyn Art Museum, Omaha, Nebraska.

in her own style, before she absorbed so much of her mentor's manner. Bouguereau and Gardner most likely shared models, but that does not mean that their figures are interchangeable. Compared to Bouguereau's, Gardner's are more individualized, less pretty. In *Dans le bois* there is a more natural-seeming interaction among the girls than is evident in many of Bouguereau's canvases.

Gardner had developed her style already in the 1860s. Hugues Merle must have thought she showed much promise, and to have liked her personally, for he invited her to share his studio and to summer with his family on the Normandy coast in 1873. Since Merle's art was part of the impetus that led Bouguereau to change his subject matter from historicizing subjects to contemporary genre, it may be wondered whether Merle's example might lie at the root of both Bouguereau's and Gardner's styles. Bouguereau may well have been Gardner's most important teacher, but Merle's contribution deserves further study.

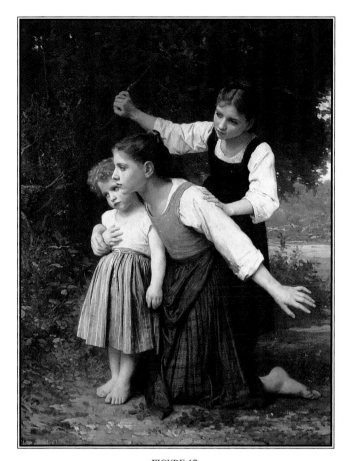

FIGURE 17.

Elizabeth Gardner Bouguereau (American, 1837–1922)

Dans le bois (In the Woods), 1889

Oil on canvas, 152.4 x 107.9 cm (60 x 42½ in.).
Photograph courtesy Christie's Images.

REPUTATION

As we have seen, contemporary critics were not kind to Bouguereau's paintings. One of the more heated responses came from Joris-Karl Huysmans, author of, among many things, the supremely decadent novel *Against the Grain* (1884). In 1879 he took aim at *The Birth of Venus*.

The *Birth of Venus* . . . is of unspeakably poor quality. The composition is perfectly ordinary. A naked woman on a shell, in the center. All around, other women frolicking in well-known poses. The faces are banal, like mannequins rotating in hairdressers' windows, but the bodies and legs are even more distressing. Take the Venus—from head to toe, it's completely unreal. There are no muscles, no nerves, no blood. The knees buckle, as if they had no joints. It's a wonder that the poor thing can stand up—a

few pinpricks and she would fall down. The color is horrible, and so is the drawing. It's as if it had been made as a design for a pillbox. The artist's hand worked all by itself, mechanically making the outline of the body. It makes me shout with rage to think that this painter, in the hierarchy of mediocrity, is a master and the head of a school, and that if we don't watch out, this school will easily become the absolute negation of art!

Bouguereau's art is a perfect example of the gulf that existed, and exists, between the hopes of the artist, the responses of professionals who criticize art for a living, and people who buy art because they like it. *Nymphs and Satyr* is a case in point. When the painting was shown in the Salon of 1873, the catalogue carried lines from the first-century Roman poet Statius. Bouguereau wanted the audience to be aware of the time-honored source of his inspiration. He was proud enough of it that he wanted to include it with his submissions to the Universal Exposition of 1878. He wrote to the owner in New York, John Wolfe, claiming that "without it, the showing of my works will be deprived of that which, I assure you, I consider as being the most significant contribution of my upcoming exhibitions." Wolfe refused, offering as his reason that its presence in the exposition would be unfair to other American collectors. It was bought from the Wolfe sale in 1882 and was made the centerpiece of the bar of the Hoffman House hotel in New York City. We can be sure that the patrons of the bar could not have cared less about an ancient Roman poem. The display of *Nymphs and Satyr* on a red velvet platform sparked a vogue for barroom nudes, a move hardly conducive to Bouguereau's art being regarded with seriousness. In a similar fashion, *Return from the Harvest* was displayed in one of the chain of movie theaters owned by Edward Albee of New York from the mid-1920s until the mid-1950s, a time when movie "palaces" were richly decorated with elaborate iconographic programs, in homage to the new technology they housed. And today, reproductions of Bouguereau's paintings are frequently the best-sellers in their respective museum shops, and the curators, responding like the nineteenth-century critics, despair over the public's taste.

It is a measure of Bouguereau's stature that his is the name most often invoked when progressive art is juxtaposed to traditional art. He is impossible to ignore. His colleagues at the Académie Julian—Tony Robert-Fleury (1837–1911; Bouguereau's partner in teaching), Jules-Joseph Lefebvre, Gustave-Rodolphe Boulanger (1824–1888)—also painted nudes and classicizing subjects in equally fine technique, yet their names are unfamiliar to all but specialists today. These artists have suffered at the hands of the immense popularity in the twentieth century of the early modernist painters—Edouard Manet (1832–1883), Monet, Degas, and Paul Gauguin (1848–1903), to name but a few. And if some of Bouguereau's subjects seem sentimental or lacking in sincerity, these traits must be seen as reflecting the mores and tastes of his time, not of ours. We are willing to accept the rapt expressions on the faces of saints by the Spanish painters Bartholomé Esteban Murillo (1617/1618–1678) or José de Ribera (1591–1652) as being embedded in their cultural circumstances, or the theatrical gestures in a history painting by Poussin or a

genre scene by Greuze as being explicable in terms of prevailing artistic theory. Bouguereau's art, too, must be understood as a product of a particular time, place, and sensibility. But even without such understanding, his paintings continue to intrigue us today. Whether as visions of sweetly sentimental, squeaky-clean childhood, a religious piety experienced by only a few, or of female nudes idealized so they function as safely remote erotic fantasies, Bouguereau's paintings are part of our late-twentieth-century visual culture.

SUGGESTED READING

There are very few books in English dedicated to Bouguereau. Some of the works listed here contain brief discussions of Bouguereau and his art and help to place him in context. Quotations throughout the text have been taken from these sources. Baschet's compendium of critical responses to Salon works, unfortunately, does not identify the source of the quotations.

Baschet, Ludovic. *Catalogue illustré des oeuvres de W. Bouguereau.* Paris: Librairie d'Art, 1885.

Boime, Albert. *The Academy and French Painting in the Nineteenth Century.* Reprint, New Haven and London: Yale University Press, 1986.

Bouguereau. Masters in Art, vol. 7, no. 82. Boston: Bates and Guild Company, 1906.

William-Adolphe Bouguereau. Exh. cat. by Robert Isaacson. New York: New York Cultural Center, 1974.

William Bouguereau, 1825–1905. Exh. cat. Paris: Musée du Petit-Palais; Musée des Beaux-Arts de Montréal; Hartford, Conn.: The Wadsworth Atheneum, 1984.

Cook, Clarence. *Art and Artists in Our Time.* New York: Selmar Hess, 1888. Reprint, New York and London: Garland, 1978.

Duncan, Carol. "Happy Mothers and Other New Ideas in Eighteenth-Century French Art." In *The Aesthetics of Power: Essays in Critical Art History,* 3–26. Cambridge: Cambridge University Press, 1993.

Fehrer, Catherine. "New Light on the Académie Julian." *Gazette des Beaux-Arts,* 6th per., 103 (May–June 1984): 207–15.

Fidell-Beaufort, Madeleine. "Elizabeth Jane Gardner Bouguereau: A Parisian Artist from New Hampshire." *Archives of American Art Journal* 24, no. 2 (1984): 2–9.

Fink, Lois Marie. *American Art at the Nineteenth-Century Paris Salons.* Washington, D.C.: Smithsonian Institution Press; Cambridge: Cambridge University Press, 1990.

Isaacson, Robert. "The Evolution of Bouguereau's Grand Manner." *Minneapolis Institute of Arts Bulletin* 62 (1975): 74–83.

Milner, John. *The Studios of Paris: The Capital of Art in the Late Nineteenth Century.* New Haven and London: Yale University Press, 1988.

Nochlin, Linda. *Realism and Tradition in Art, 1848–1900.* Sources and Documents. Englewood Cliffs, N.J.: Prentice-Hall, 1966.

Rosenblum, Robert, and H. W. Janson. *Nineteenth-Century Art.* New York: Harry N. Abrams, 1984.

The Second Empire, 1852–1870: Art in France under Napoleon III. Exh. cat. Philadelphia: Philadelphia Museum of Art, 1978.

Strahan, Edward [Earl Shinn]. *The Art Treasures of America: Being the Choicest Works of Art in the Public and Private Collections of North America.* 12 vols. Philadelphia: George Barrie, 1879.

Vachon, Marius. *W. Bouguereau.* Paris: A. Lahure, 1900.

Weinberg, H. Barbara. *The Lure of Paris: Nineteenth-Century American Painters and Their French Teachers.* New York: Abbeville, 1991.

Weisberg, Gabriel P., with Petra ten-Doesschate Chu. *Redefining Genre: French and American Painting, 1850–1900.* Exh. cat. Washington, D.C.: The Trust for Museum Exhibitions, 1995.

Whiteley, Linda. "Accounting for Tastes." *Oxford Art Journal,* no. 2 (1978–79): 25–28.

Zafran, Eric. *French Salon Paintings from Southern Collections.* Exh. cat. Atlanta, Ga.: High Museum of Art, 1982.

INDEX OF PLATES

INDEX OF FIGURES